THE RODIN MUSEUM, SEOUL

TO KUREA,
ALL THE BEST!

Kim 6/25/02

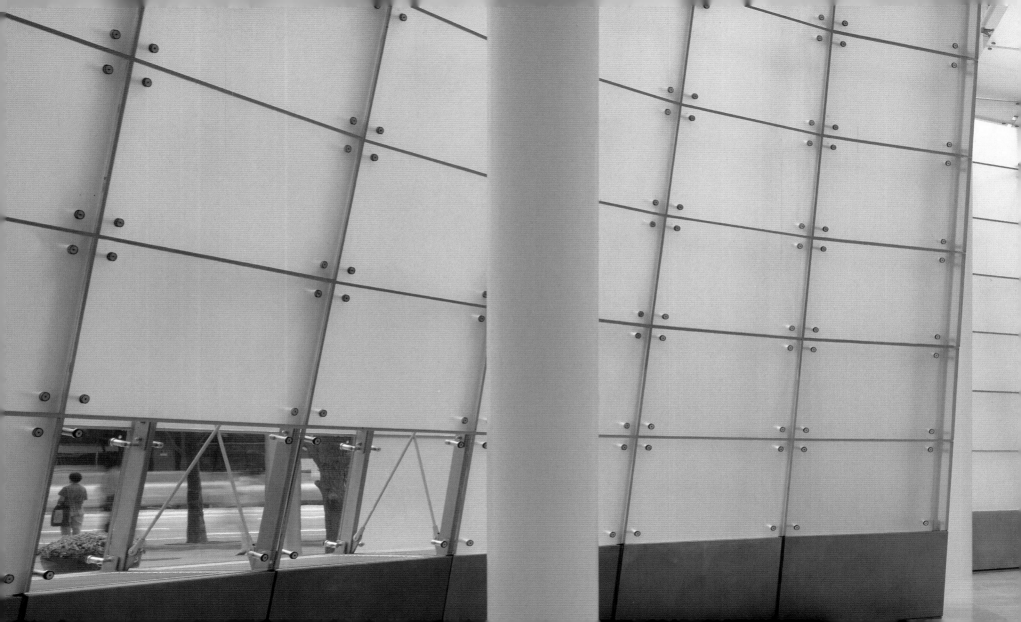

THE RODIN MUSEUM, SEOUL

Kevin Kennon
of Kohn Pedersen Fox

with essays by
Ruth Butler and Mario Gandelsonas

PRINCETON ARCHITECTURAL PRESS

For Greg Clement
collaborator, partner, friend, and brother

PRINCETON ARCHITECTURAL PRESS
37 East 7th Street
New York, NY 10003
www.papress.com

FIRST EDITION

Printed and bound in Italy

EDITOR: Eugenia Bell
BOOK DESIGNER: Mia Ihara

Cover photo by Timothy Hurley

SPECIAL THANKS TO:
Ann Alter, Amanda Atkins, Nicola Bednarek,
Jan Cigliano, Jane Garvie, Caroline Green,
Beth Harrison, Clare Jacobson, Mark Lamster,
Anne Nitschke, Lottchen Shivers, Jennifer Thompson,
and Deb Wood of Princeton Architectural Press
 —Kevin C. Lippert, Publisher

Library of Congress Cataloging-in-Publication Data is
available upon request from the publisher.

Contents

Acknowledgments

To build any building requires the talents and skills of many people. To build the Rodin Museum, the number of people to the proportion of space far exceeded the norm. To name everyone would be to fill a volume with names of people worldwide. One of the stranger aspects of designing a building is that you are only able to have a personal connection to a very small percentage of those names. It is for this reason that I believe the whole concept of "authorship" is foreign to architecture.

There would be no Rodin Museum if it were not for Madame Hong of Samsung. Her sensitivity and insight helped define the building. If she had not given her support, I doubt anyone else would have taken the risk. Mr. Seung-Han Lee and Mr. Won-Jeong Kim from the Samsung Office of the Executive Staff were also instrumental in their support of the project.

We were fortunate to work with a great Korean architectural firm, Samoo. Mr. Ju Hwan Cho led an excellent team of architects. We are especially grateful to Mr. Woo-Chun Rah for his tireless efforts as the project manager for Samoo. He was ably assisted by Mr. Tae-An Kang.

The Samsung Construction Company supervised the building of the museum. Of special note is the dedication of Mr. B.G. Choi, whose job it was to procure materials for the project. I have never met anyone with more energy.

The museum was constructed by Josef Gartner and Company of Gundelfingen, Germany and led by Hans Siedentopf. The museum stands as a legacy to his genius for realizing the impossible. His chief engineer Eugen Seefried, and project manager, Peter Langenmeyer, embodied a creativity I did not think possible. No other company could have produced the same museum that stands today.

The glass for the museum was provided by Vegla and engineered and manufactured by Bruder Eckelt and Company of Steyr, Austria. Eckelt has a wonderful history of producing cutting-edge glass. The Rodin Museum draws extensively on their experience and skill.

We could not design this building without the help of many consultants. The New York office of Ove Arup and Partners engineered the building. Led by Ray Crane, principal in charge, the Arup team became our primary collaborator. Special thanks goes to Matt King for his sheer brilliance and design skill. I also would like to thank Cosentini Associates, under the leadership of Doug Mass, who came up with the brilliant solution of a duct-free system for the heating and cooling of the museum.

I consider myself fortunate to work at Kohn Pedersen Fox. I owe a special debt of gratitude to Bill Pedersen. Not only is Bill the finest architect I know, but he is also unique among his peers for his generosity. Gene Kohn has created a firm where design comes first and talent is given free reign.

Above all, KPF attracts great people. The friendships that develop through working together as a team are as meaningful to us as the work we produce.

The Rodin team was nobly lead by Greg Clement, with whom I have collaborated on many projects. His wisdom and skill is only surpassed by his keen sensibility. It is because of Greg I am writing this.

Andreas Hausler, Matt King, and I spent quite a bit of time together in Germany during some particularly challenging moments. Andreas embodies the craft of architecture with every fiber of his being. His relationship with Gartner enabled the museum's design to overcome the transition from drawing to building with as little alteration to the design concept as possible.

Greg and I were lucky to have a great team behind us. Led by Marianne Kwok and Luke Fox, the team consisted of John Locke, Francis Friere, Cordula Roser, Michael Marcolini, Vlad Balla, Aida Saleh, Chris Ernst, Andrew Kawahara, and Trent Tesch. Luke Fox in particular lived, ate, and breathed the Rodin Museum for two years.

At Princeton Architectural Press I would like to acknowledge the hard work of my editor, Eugenia Bell, and the book's designer, Mia Ihara. I would also like to thank Kevin Lippert, who had the foresight to publish this project as a book.

I thank Kristen Danzig for all of her efforts in organizing the book project. I owe everything to Stacie Wong of KPF. She took on the responsibility of coordinating our efforts for the book even though she was simultaneously designing three other buildings.

Finally, the sun rises and sets on my family: Molly, Bailey and Max.

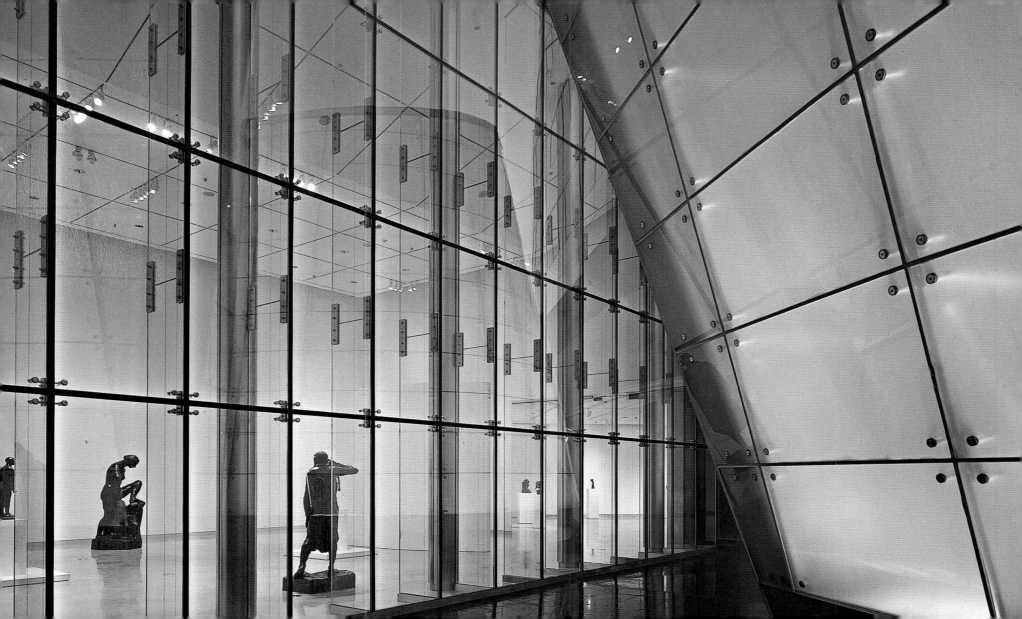

Globalism and the Zeitgeist

KEVIN KENNON

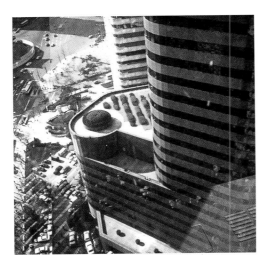

The subtext of most architectural criticism is that commercial architecture has become so dominated by real estate developers that it has ceased to be a viable arena for making culturally relevant artifacts. This way of thinking diminishes commercial architecture to merely a commodity. But even a commodity has cultural value. And the differences in the value of things between different cultures create identity. Buildings are merely man-made artifacts that represent this identity.

Architecture critics rank which building types best illustrate cultural paradigms. Typically, those that signify the mere economy of power rank lowest while institutional buildings like libraries and schools rank higher as they are more obviously suited to the greater cultural and social good. Underlying almost all contemporary criticism is a belief that architecture needs to reflect the spirit of the age. More precisely, it should represent cultural shifts that are ideological rather than economical. Architecture that is difficult, destabilizing or unique, and yet ultimately inspiring, appears to the modern critic to better represent these paradigm shifts. There is no evidence (other than prejudicial) to assume that commercial architecture cannot create this type of critical architecture. It may be true that the prevalence of these biased views makes it extremely difficult to find buildings that address the cultural *zeitgeist* in corporate architecture. Commercial buildings that point the way to some new conception of the world would appear to be nonexistent. Yet they exist and the Rodin Museum in Seoul is one of them.

The world of commercial architecture is swimming with opportunities to create critical architecture, especially in areas overlooked for being a-typological, too small, or just risky in a typical corporate practice. The critical architect in a commercial practice must have an eye for identifying the projects no one else wants to do. In a sense she is a scavenger for the marginal, the detritus that gets caught in the wide net trawling for big, corporate fish. Rather than discarding this flotsam she uses it to create an alternate architecture. Alternate precisely because it falls outside the definition of viable commercial architecture. Their very otherness invests these leftover buildings with the possibility of freeing themselves from the mere representation of corporate power.

But this "found architecture" is itself a critical activity. Indeed, it is one of the legacies of modernism, specifically Dadaism, that the ability to read our physical environment is as much a creative act as the ability to make it. This concept carries with it the possibility that architecture exists beyond the intentions of the architect or the prejudices of the critic. This strain of thinking which in art has a distinct lineage: Duchamp–Beuys–Hirst is perhaps best represented in contemporary architecture in the work of Rem Koolhaas. For Koolhaas the distinctive categorization of building typologies no

longer has cultural relevance. He plays against accepted categories to invest his architecture with new meaning.

Of course Koolhaas is outside commercial architecture and can more realistically claim retail architecture, for example, as having cultural significance beyond mere entertainment. Those of us working inside the system have greater difficulty in representing this kind of alternative. We are tainted by being too close to the beast in the eyes of the critic. Commercial architecture is for them the domain of lesser talents with no vision at best, and as witting accomplices in the rape of culture at worst. Suffice it to say that bad architects are not exclusive to corporate architecture. Only critical prejudice keeps commercial architects from conceiving a practice that strives for cultural relevance. Most therefore do not even attempt the exercise.

The opportunity to design the Rodin Museum arose from an obscure document outlining a program to renovate the base of the Samsung Headquarters building in Seoul, Korea. The program made marginal notation of various other elements that could expand the program, including a new lobby for the adjacent Samsung Life Insurance building, a new automobile drop off for the chairman, a renovation of the underground retail area, new entries from the street to the retail area, an urban plaza, a parking tower, a commemorative garden, and an exhibit space for two Auguste Rodin sculptures.

Duchamp was always in mind during the design of the Rodin Museum. The dark bronze figures trapped in a space of laminated glass are reminiscent of *The Bride Stripped Bare by Her Bachelors Even*. The cracked glass in both the museum and *The Bride* were accidents that were left in the final product as small discoveries.

We felt that there was a poetics to this list which was Borges-like in its litany. This list, perhaps because it was so non-hierarchical, drew little interest from many in the office, as it appeared to be just another lobby renovation job. In fact, Samsung had tried out quite a few other architectural firms for the job before coming to KPF. Most failed precisely because they did not see the lyrical possibilities of the program.

If the program for the project was a maze, then the site was the maze from Kubrick's *The Shining*. The Samsung headquarters faces TaePyong-Ro, the main 12-lane artery in downtown Seoul. It occupies a sacred place in Korean cultural memory since it is adjacent to the South Gate, the ceremonial entrance to the old city. There are not many traces of that city as evidenced by the traffic circle ringing this most sacred artifact. The red granite Life Insurance Building adjacent to Samsung headquarters was oriented at a 45-degree angle to the TaePyong-Ro. A side street that also functioned as an entrance to the Samsung enclave separated both buildings. On the other side of the headquarters, the Joong An Industry Building had just broken ground. A green stone box, it was slimmer but almost the same height as the Samsung tower.

The site and the program had a lot in common despite their apparent incongruity. Adding to this displacement was the lack of a single client—each built component of the program was separately owned. Approval for the design of the lobby was given by the Samsung Life Insurance Company, the retail entries by the Samsung Trading Company, the plaza by Cheil Communications Company, etc. As far as our clients were concerned, this project was essentially about transforming their underground retail department store into an American-style high-end shopping mall. In the client's initial conception, *The Gates of Hell* was placed at the main entrance of the mall to act as a draw from the street!

Yet the very disparity of the site, program requirements, and many-headed ownership provided us with a way of reading and creating an architecture of memory. It was impossible to create a singular urban complex centered on an open plaza in the manner of New York's Rockefeller Center. Rather each piece of the program was treated as a separate intervention. Though distinct, we felt it important that the pieces share a common formal and material vocabulary. As these interventions were strung out along the street like so many beads on a string, there was no single vantage point with which to grasp the entire composition with clarity. The totality of the design could only be grasped mnemonically. Hierarchy in the traditional sense could only be visually suggested since each piece would be viewed individually.

While we stripped away the existing white granite colonnade at the base of the main building, we marked its absence by placing new stainless steel pylons in the exact spots of the preexisting granite piers. We even extended this three-

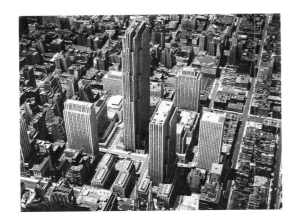

Rockefeller Center, New York City, in 1954.

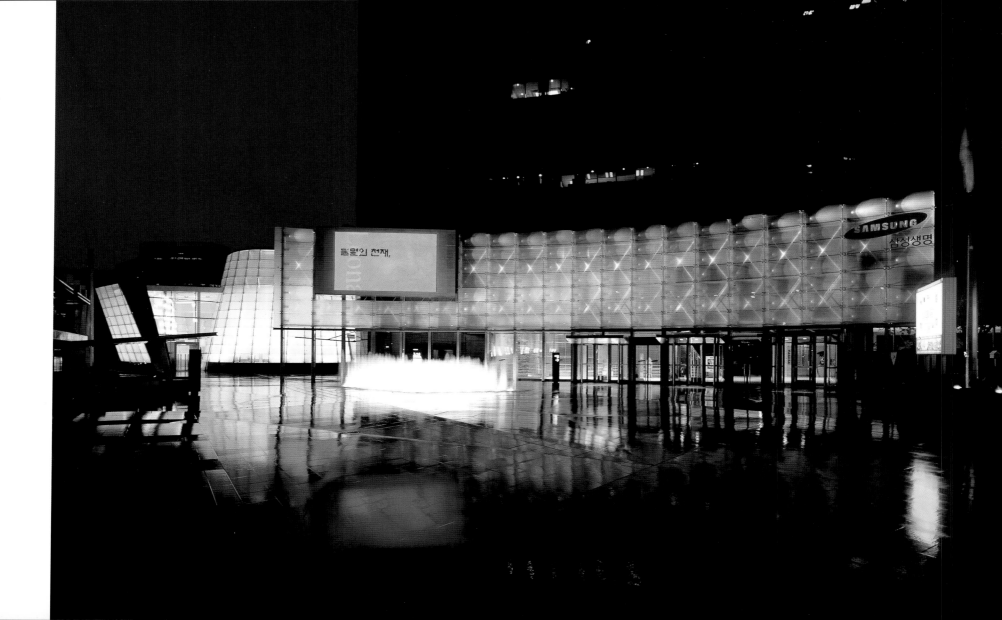

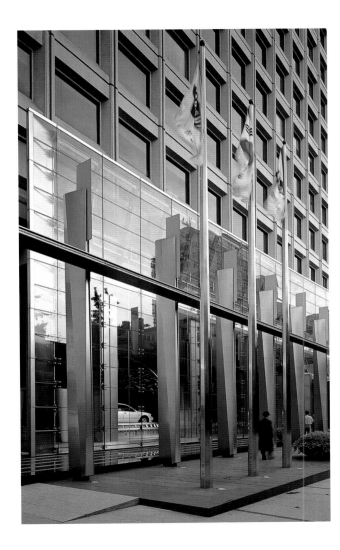

meter rhythm of pylons across the entire length of the street frontage to link the disparate built events together.

Given that the existing buildings on the site were all made of different colored stone, glass was our material of choice. Its contrast against the stone, its enigmatic quality always generates something extra. Glass is unique among architectural material because it is at once transparent, translucent, and opaque, depending on the vantage point of the observer. The ambiguity inherent in the material offered a tantalizing way of reflecting the disparity and unity of the site, program, and ownership.

Each installation was linked by a formal variation on the curve. The initial impulse was again to create a contrast between the primarily rectilinear buildings on the site and the new intervention. We were interested in exploring fragmented curves to reinforce the distinct character of each piece. The elusive nature of the curves fold space in such a way as to make it difficult to distinguish inside from outside. As we utilized these installations as both interior and exterior conditions we felt that this ambiguity played with the observer's perceptions of the urban condition. This elusiveness was particularly important in the design of the museum since we wanted to create a feeling of being outside even when one is enclosed and separated from the hubbub of the street.

The design of the museum was born of this complicated reading and the many details of the program. Rather than attempting to synthesize all these elements into a whole as other architects had attempted we found extant urban conditions that offered the opportunity for play. This play became a way of dealing with the challenges of working in another culture without imposing a western worldview or restricting ourselves to Korean architectural traditions. Our goal was not to resolve cultural difference but instead to provoke multiple readings and questions about the differences.

This then is the responsibility of the commercial architect intent on working both globally and critically. As any cultural anthropologist will attest, it is only by engaging oneself in the world as if we do not occupy its center that we can ever hope to shed the straightjacket of our narrow cultural hegemony. By finding an alternative architecture within the conditions and restrictions of a program, we attempted to suggest a way that commercial architecture can play a role in the larger cultural discourse of globalism and the *zeitgeist*.

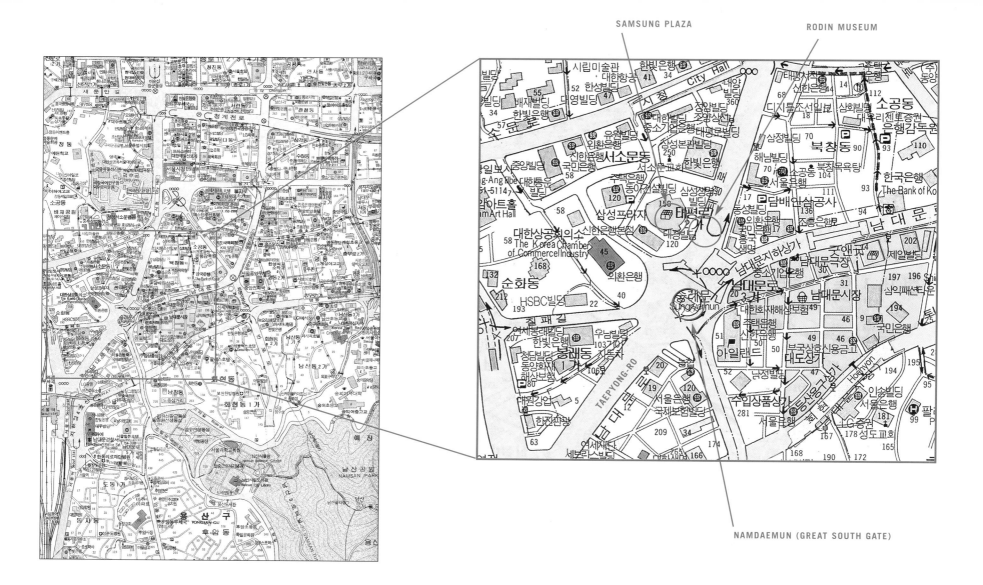

SAMSUNG PLAZA

RODIN MUSEUM

NAMDAEMUN (GREAT SOUTH GATE)

The See-Through Museum

MARIO GANDELSONAS

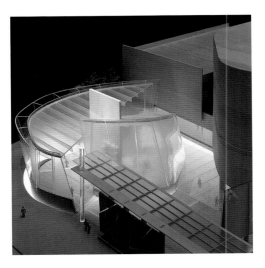

It has been two years since the jewel-like museum first appeared as a luminous addition to the Seoul skyline. Built to house Rodin's *Gates of Hell* and *The Burghers of Calais*, the Rodin Museum was designed as part of Samsung Plaza, a corporate development which also included two high-rise structures, a small public plaza, and a large indoor mall.

Designed by Kevin Kennon, a young partner at KPF, the new building radically inhabits one of Seoul's most important intersections. Situated along TaePyong-Ro, the city's historical axis, the building experiences a simultaneous relationship to NamDaeMun (Great South Gate), the main gate to the ancient city, and KwangHwaMun, the main gate to the KyongBokKung palace—the political, symbolic, and geometric center of the city since its establishment as the capital in the late-fourteenth century.

To Kennon's credit, the Rodin Museum inhabits both the site and Seoul in a way that suggests a new dialogue between cities and buildings. Activated in the x-urban sense, the building postulates a new practice of placing architecture within an urban context. While the pre-modern city postulated the monument as the chief figure within the city's ground, and the modern city gave the role of figure to its heroic buildings, in contemporary x-urbia most buildings become either ground for a new figure—the media—or containers for an increasingly interiorized urbanism, where a multiplicity of public spaces transforms the traditional opposition between public and private. The Rodin Museum primarily plays this role by blurring the simple oppositions that relate it to old monuments through the subtle complexity brought into play by its design. This is particularly the case at night when the building, ablaze with light, acquires a prominent role in Seoul's nocturnal constellation of signs, buildings, and spaces.

The museum space itself articulates and interrelates, while simultaneously modifying, the relationship between two fields of forces: the existing outdoor urban landscape and the new interior. While the contrast between the traditional sculptural elements of the stone Great South Gate and the dynamic glass outer surfaces of the museum creates a powerful urban moment, the use of transparency, translucency, and opacity enables the building to suggest what lies within without revealing itself wholly to the outside.

Conceived as both a background for the sculptures and as a means for choreographing their viewing, the interior organization of the gallery situates itself between the rapid pace of urban viewing and the slower, more contemplative pause of the museum visitor. The use of translucent glass accentuates the mediating role of the museum building, allowing light but not vision, thus blurring the sculptures into shadows through a very

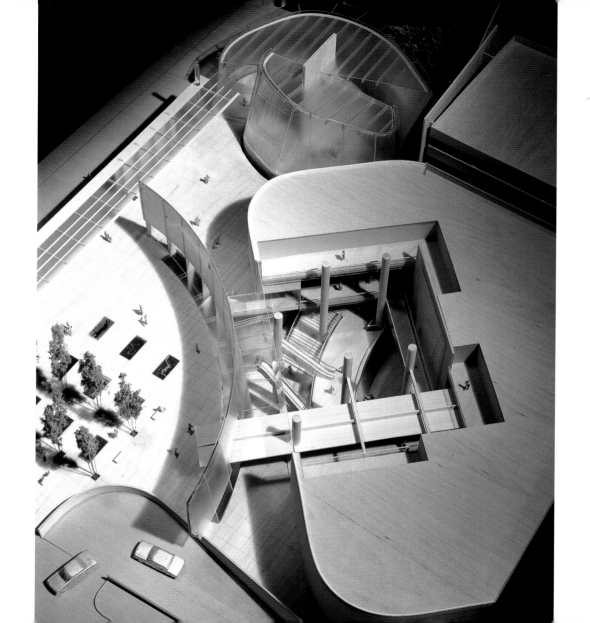

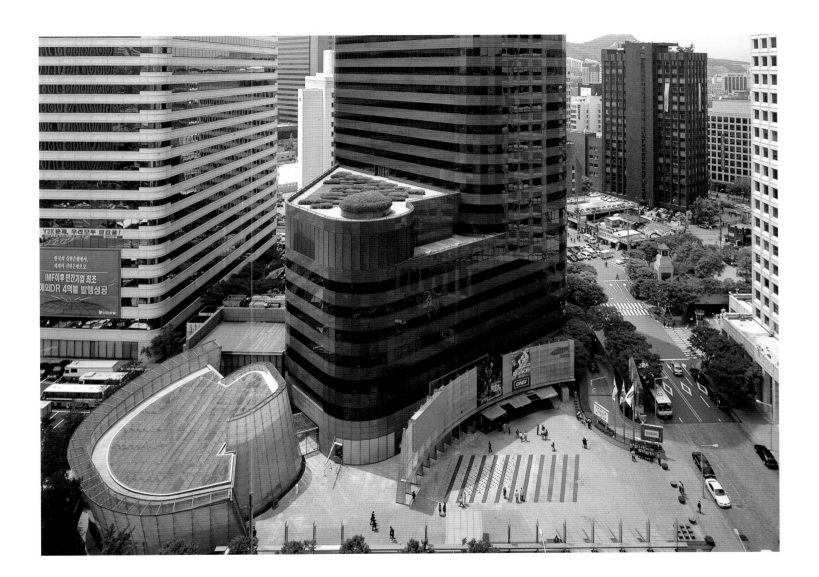

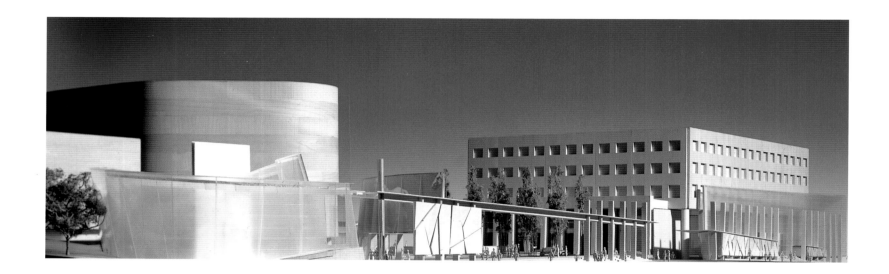

large window whose inner glazing is finely shattered, laminated glass. Passing by at night, *The Gates of Hell* and *The Burghers of Calais* hover as two unrecognizable and indistinct dark forms within their glowing chamber.

Choreographing the interior space of the gallery around these two works, Kennon's building encloses the viewer in a diffuse interior space in contrast to the dull sheen of the outer translucent glass. With translucent walls and ceiling and an ivory colored stone floor, the space has a chapel-like quality. Further, because the two sculptures—

widely divergent in content—are the only objects in the space, a remarkable tension dominates. It is a space in which reflection is not only allowed, it is demanded.

The Burghers of Calais and *The Gates of Hell* were commissioned in the 1880s. Originally intended as doors for a new museum that was never built, *The Gates* became the object of a crucial process of transformation and variation between 1880 and 1917, the generator of multiple experiments with its individual figures of which *The Thinker* is the best known example. Critic

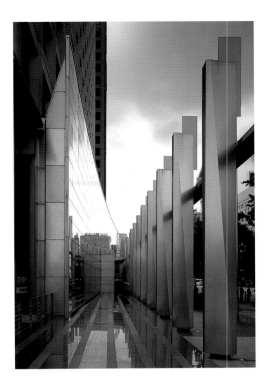

Rosalind Krauss, in her article "Narrative Time: The Question of *The Gates of Hell*," proposes that the whole of Rodin's œuvre can be found within this single project. Further, the location of the Rodin Museum in Seoul next to *The Great South Gate*, brings to mind the association between *The Gates of Hell* and the Arc d'Triumph proposed in Krauss' piece.

The sculptures themselves propose radically different conditions for viewing. While sculpture traditionally works with space and time by requiring movement towards the production of narrative, the frontality of relief is deceptive in that it often gives the illusion of providing the same information without actually making good on the promise. The comparison that Krauss establishes between Rodin's *Gates of Hell* to Francois Rude's sculptural commission for the Arc d'Triumph in Paris serves to elucidate Rodin's modernity as an attempt to paralyze narrative through a series of different formal strategies.

The museum appears to be dedicated to the same end. The group of *Burghers*, located axially to the entrance, is the initial draw into the space. As one moves towards the figures, however, the space opens up to the right, revealing the greater extent of the gallery. A column obstructs the view of *The Gates of Hell* until a critical point at the intersection of two lines—the line from the entrance to *The Burghers* and the line running perpendicular to *The Gates of Hell* out toward the street. If one were to turn sixty degrees at this point along the approach to *The Burghers*, *The Gates* would be straight ahead. Here, with the columns no longer obstructing the view of the gallery or *The Gates,* the viewer's visual field is entirely cleared. One is finally inside the space, a moment marked by widely varying impressions—awe at seeing *The Gates of Hell* for the first time and studied contemplation upon realization of the full extent and character of the surroundings. A bench is provided for the visitor to help mark the inner sanctum. Its distance from the work allows for contemplation of *The Gates* in their entirety, although a closer viewing requires that the visitor approach the sculpture.

The techniques of display employed in the gallery, working through the distinct nature of each piece, play off the tensions of the gallery's spatial choreography. *The Burghers*, as objects in the round, float in the middle of the space against the background of the surrounding gallery's translucent glass. A small stainless steel railing surrounds the sculpture and a second ceiling hangs slightly lower than the one above it to further demarcate the sculpture's space. Inverting the display paradigm of *The Burghers of Calais*, *The Gates of Hell* are installed along the perimeter of the gallery in a curved alcove and are approached and viewed frontally. Above, the hung ceiling is removed and a skylight is added, heightening the space to views of the outside.

The second entry sequence, that of entering the gallery from the shopping mall is in many ways symmetrical to the first. There is the same act of deferral, of tension, of veils and hidings. As one approaches the top of the stairs, *The Burghers of Calais* are first perceived in a rear, oblique view. Once past the curve of the stairs, *The Burghers* face away, pulling the viewer around to the front of the sculpture where *The Gates* come into view. The role of the two entrances, street and shopping mall, is to integrate the gallery into the urban experience, not as part of a formal sequence but as part of a programmatic one—driving, viewing art, shopping.

PLATFORM

Historically, pre-modernist and modernist museums were conceived as enclosed structures—viewing machines for the exhibition of rare artistic objects. These machines positioned the work and the viewer and constructed the space surrounding the objects in regard to its shape and lighting. Starting with Schinkel's Altes Museum, however, the museum began to look outward, focusing the viewer's attention not only on the objects of its collection, but on the city itself. From Schinkel's building through which the panorama of Berlin can be seen to I.M. Pei's extension to the Louvre which articulates the either/or of the modern condition with its intended oppositions: museum/shopping, art/life,

high/low, museums have consistently created a platform for viewing and experiencing the city.

The Rodin Museum proposes a building that reframes the museum as visual platform vis-à-vis the contemporary x-urban city by blurring the modernist oppositional paradigms previously in place. Kennon produces a visually permeable building, where two glass walls establish boundaries and at the same time erode them with their translucency, and where multiple windows blur the oppositional relations that separate the interior and the exterior, the public and the private domains.

This is particularly manifest within the building's interior. The two walls that configure the gallery space express very different dynamics. The long wall is unstable, moving the viewer from the door to the stairs, from the entrance to the exit, and vice versa. It half-frames a space of which the other half is implied—a space which *The Burghers of Calais* command. Creating the apse that frames *The Gates of Hell*, the shorter wall is more stable. While the long wall suggests a deformed circular plan of which only one half is marked, the short wall reads as the missing half, morphed or shrunk: a frame. It also suggests that the internal motion possibly continues in the open space outside the building—its shrinking evidence that the space is able to leak in and out of the building.

Such are the symptoms of walls that no longer perform their classical or modernist roles—in the

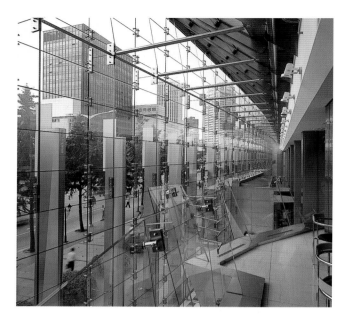

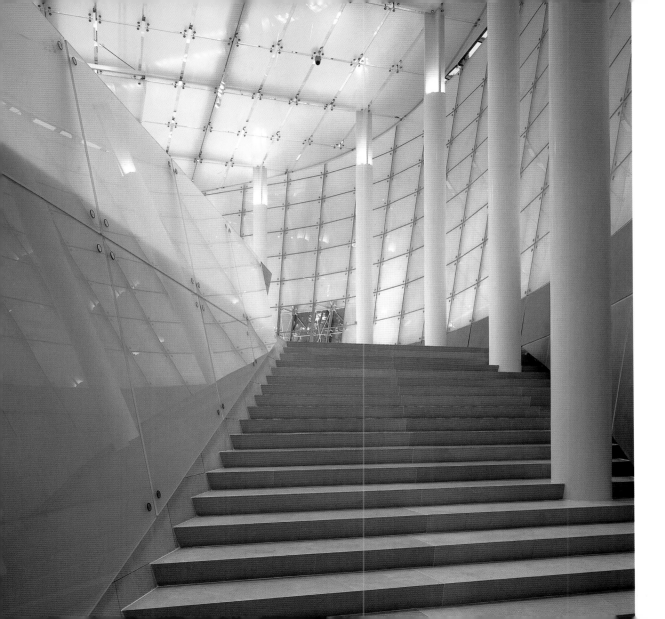

first case, separation and support, and in the second, merely separation. In the gallery the walls formally establish a boundary and then proceed to erode it with their translucency. The sculptures are half enclosed, half exposed, their glass enclosure eroding by day the opposition between outside and inside. By night the sculptures are both protected and exposed, objects in the shop window, their presence obscured yet visually public while privately kept out of reach. The glass walls are not modernist windows becoming walls but rather walls becoming windows, filtering light and blurring vision.

Multiple windows open the walls to various views from the city, of the city, and to the adjacent gallery, reinforcing the space's transitional quality. From the outside the windows provide glimpses of the building and a mysterious veiled image of its contents. From inside the windows allow for the city's constant presence and connect the art of the adjacent gallery to the world of consumption offered by the complex's subterranean shopping mall.

Both windows and walls seem to further manifest the building's position as steadfastly between the speed of urban shopping and the languor of the museum visit. By placing the two side by side it subverts the notion that they are activities predicated on separate practices. Perhaps meandering reverie and high speed shopping are both necessary approaches to the museum within the x-

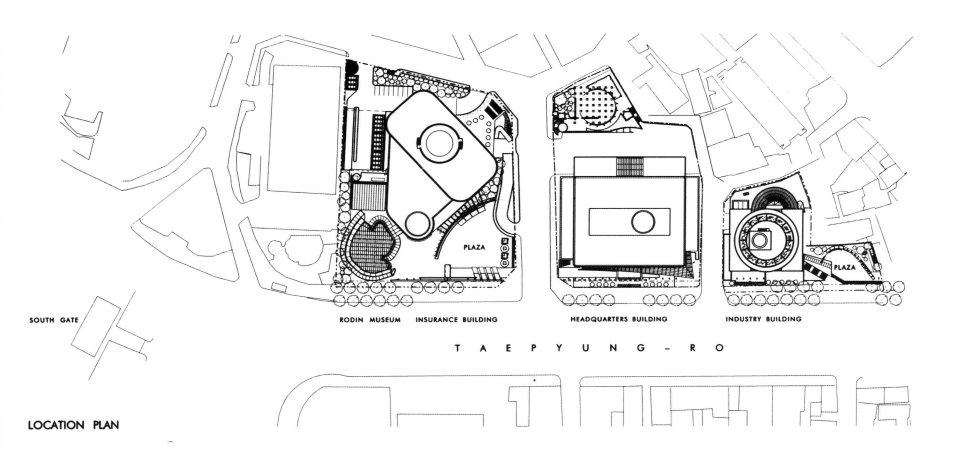

SOUTH GATE

RODIN MUSEUM INSURANCE BUILDING

PLAZA

HEADQUARTERS BUILDING

INDUSTRY BUILDING

PLAZA

T A E P Y U N G - R O

LOCATION PLAN

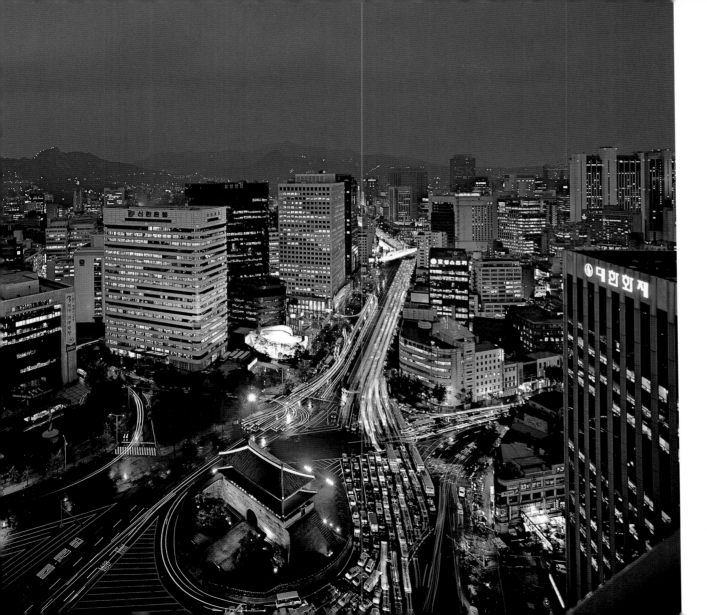

Perhaps, and then perhaps not. For as the x-urban city proposes new conditions for the practice of an urban architecture it is also aware that the challenge of architecture is to both engage with speed—that is attract our attention—and at the same time present a resistance to speed and therefore to the glance as the only option for reading the city. Inspired perhaps by the slow glance required by Rodin's sculpture, the architecture of the Rodin Museum proposes that there is something left unfinished by the glance, that there is something else besides image and spectacle that architecture and the urban text must access. Perhaps, then, the slow time of reflection is required if one is to critically read the city.

The nighttime scene along TaePyong-Ro with the Great South Gate at the bottom and the Rodin Museum in the center

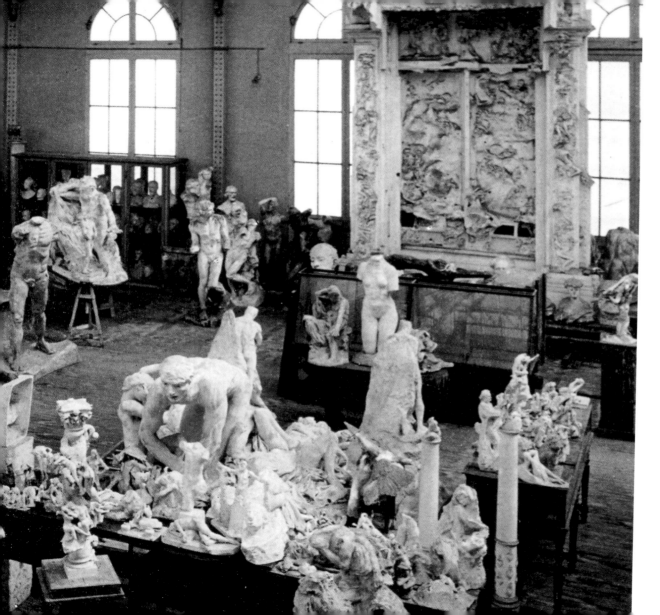

Inside the pavilion d'alma in Meudon with a version of
The Gates in the background, c. 1916

A Musée Rodin for Korea

RUTH BUTLER

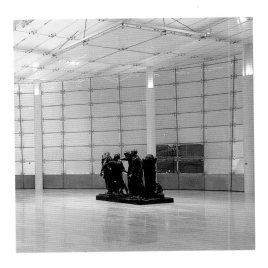

When Kevin Kennon was called on by the Samsung Group in February of 1995 to design a gallery, it was clear he was not embarking upon another "corporate" commission. The siting of a small gallery in a busy high-rise urban center on an eight-lane street—a gallery intended to house Rodin's *Burghers of Calais* and his *Gates of Hell*—presented a formidable challenge. These two works, the focal point of the new gallery in Seoul, already exist in the form of alternate casts in museums around the world. The majority of patrons, officials, and curators responsible for installing these earlier versions of *The Gates of Hell* and *The Burghers* felt the public would best be served by seeing such complicated, emotionally packed bronzes in the full light of day. But Kennon was asked not only to enclose them within a small gallery, but on the site of Samsung's urban corporate campus—on the busiest thoroughfare in Seoul. His success exceeded what anyone involved imagined possible and pleased the eager art and architectural communities.

Rodin was by no means unknown to South Koreans when the new gallery was proposed. Just as elsewhere in the world *The Thinker* is renowned, if only through its continuous reproduction in the media, and this meditating modern Buddha has had enormous appeal in Asia. In general, Asians have been attracted to Rodin and his work as to no other Western sculptor, and the Japanese have led the charge of this overwhelming embrace. In 1900, the Japanese visited the Paris Exposition Universelle in significant numbers. Visitors returned to Japan with reports about the art at the expo, with particular enthusiasm for the sculpture and drawings of Rodin. The sculptor began to receive regular visits from Japanese artists and collectors, and by 1912 was exhibited regularly in Tokyo. Rodin was extremely enthusiastic about his new connection to the East.

The most well known early Asian collector of Rodin's sculpture was Baron Kôjirô Matsukata. He visited Europe for the first time in the spring of 1916 and by 1920 was in contact with Léonce Bénédite, director of the newly established Musée Rodin in Paris. Matsukata ordered the first bronze cast of *The Gates of Hell*, a commission carried out by the Rudier foundry. Completed in 1926, the cast did not reach Japan until 1959. Japanese tax laws, World War II, and French bureaucracy took turns in inhibiting the eastward journey of the first cast of *The Gates*.

The story of Matsukata's door reminds us of the powerful non-art issues that effect the universal knowledge and acceptance of the art of others. Modern art came to Korea under the auspices of the Japanese who ruled the peninsula from 1910 to 1945. The earliest generation of modern artists from Korea studied in Japan where they became aware of Western art. And the Japanese, the first in Asia to be attentive to Rodin's art, have continued to build the most significant collections of his

work in the East. There can be no doubt that we are witnessing a competitive initiative in the creation of a Rodin Gallery in Seoul. That its achievement stands up so well in the competition is due to the outstanding setting created by Kevin Kennon and Kohn, Pedersen, Fox.

That Rodin would be the leading Western sculptor to capture the hearts of Asian audiences is not surprising. They recognize in his work the hand of a master modeler, and modeling is the root of Asian sculpture. Further, the East has always had a significant tradition of bronze casting. Yet, it is more than that. What makes Rodin so accessible to non-Westerners is a method of modeling that particularizes physiognomy or stresses characteristics of racial types. His summary style captures universal emotions—expressions of fear, envy, love, lust, and grief—so directly that viewers do not immediately think about the French identity of *The Burghers*, and even less so with the *Thinker* and the other figures in *The Gates of Hell*. To watch crowds in Beijing, Tokyo, Shizuoka or Seoul pressing around Rodin's figures is to counter an intensity, a kind of amazement seldom encountered in the museums in Paris and Philadelphia.[1] A Western audience familiar with Rodin's work can witness the exorbitant and emotionally charged nature of his work with a certain distance. Not so with most Asian art lovers. These audiences gaze upon his figures with concentration—even awe—and they are more likely

to divine spiritual qualities in Rodin's work. Nowhere is a setting so perfect in aiding such discovery as the Rodin Museum in Seoul.

Visitors move from the crowded sidewalk and busy street into the cool and luminous space of the Seoul museum. It seems larger than its 5,000 square feet. *The Burghers of Calais* are near the entrance and at the far end of the gallery is *The Gates of Hell*. That the placement is not arbitrary nor variable is clear from the panels of the glass ceiling, perfectly corresponding to the perimeter of *The Burghers*, which have been slightly lowered over the place reserved for the group's installation. Some of the individual *Burghers* turn as if to greet a visitor, while the main thrust of the group is pulled in the direction of *The Gates*. The gesture results in both communication between the two works and an energy within the enclosure. The only other object in the space is a low-lying slab of polished limestone placed near *The Gates*. It is almost invisible against the limestone floor. Yet it is the one place where one can sit and contemplate the masses of figures tumbling across the irregular surface under the brooding eye of *The Thinker*, all held within the bronze frame. Or, from where one can pray, for slowly the visitor understands that in some sense this is a chapel for modern man, one in which medieval *Burghers* have become companions, *The Gates of Hell* an altar.

Rodin received both commissions in the 1880s when he was in his forties. It was the most prolific

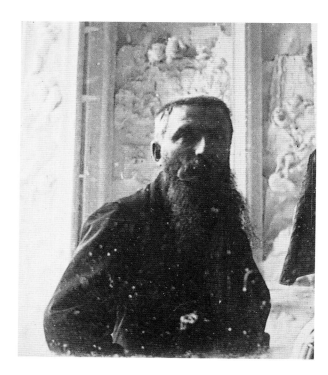

Rodin reflected in a mirror in front of *The Gates of Hell*, 1887

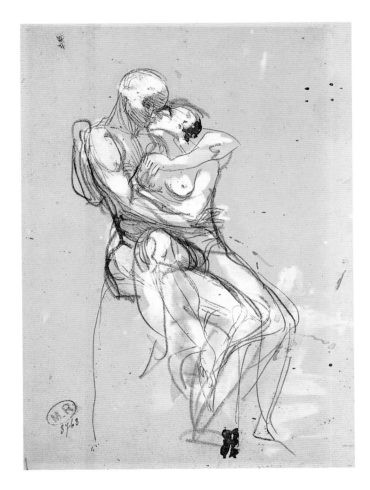

An 1880 sketch of Paolo and Francesca

decade of his life. Taken together these two pieces represent his highest achievement. An official of the French government commissioned *The Gates* (which did not receive its name until after Rodin had been working on it for five or six years) in 1880 for a new museum, one that was never built. Rodin's portal was neither cast in bronze nor installed on a public building in his lifetime.

Rodin's initial inspiration for the subject of the doors was Dante's *Inferno*. He made drawings related to specific scenes from the poem, and some figures such as Ugolino and Paolo and Francesca are identifiable in the relief. But *The Gates of Hell* do not illustrate Dante's work. Rather, Rodin created a work of parallel power with hundreds of figures—men, women, and children—turning and twisting upon the relief surface under the watchful gaze of the *Thinker* who has assumed the position of Christ as would be found in a traditional Christian portal of the Last Judgement. Above the *Thinker* stands the *Three Shades* mournfully crowning this depiction of mankind's torment. For the most part Rodin's sinners and sins are unnamed. We know only of their suffering, which is taking place in our time and our space, one in which the light from above washes over the surfaces to reveal the struggle of the dark, gleaming bodies before us.

The installation of *The Gates* in Seoul augments the power of the work, making clear that the suffering seen here is timeless and not imbedded in a scheme only relevant to a nineteenth-century audience. An aspect of this reading of the relief is the placement of *The Burghers of Calais*. Those figures relate both to the visitors as they enter from the street and to *The Gates* at the far end of the gallery, and tell the visitor that it is to *The Gates* that he or she must proceed.

The city of Calais, in northern France, gave Rodin his first opportunity to create an important public monument. The city fathers planned to commemorate heroes of its early days, citizens who had offered themselves as hostages to the English in order to save the city from destruction during the Hundred Years War. Eustache de Saint-Pierre was the first to step forward; five others followed.

The standard approach of a nineteenth-century sculptor when faced with such a commission would have been to focus upon a solitary figure but Rodin chose to give equal attention to all six. *The Burghers'* figures are depicted stripped of their worldly possessions. They are sacrificial lambs, but not necessarily free from guilt. The notion of the monument having a penitential aspect about it has never been suggested in quite the way that it is as a result of its installation in Seoul.[2]

When Lee Kun-hee, the chairman of Samsung Corporation, and his wife, Lee Hee-ho, made the decision to create a Rodin Museum for Seoul, they entered into a global competition for Rodin collections the world over. Why this energy to collect

the work of a single sculptor on such a vast scale and, more importantly, why Rodin? The answer lies in a unique convergence of circumstances.

When the Republican government commissioned Rodin to make a set of bronze doors for a new museum of decorative arts, it never occurred to him that the museum would go unbuilt and that he might never see his doors installed in a public space. But as the decades passed and it became clear that the doors were going nowhere beyond the entrance of his own studio, Rodin was increasingly intrigued by his plaster model. He became attached to it; it was his companion. He could also neglect it for years at a time and then return to it to make changes. He endlessly combined figures from the relief in new combinations. He would have multiple plaster casts made of a single figure, then break it up and see where the parts fit in. As the years wore on and he understood the special power of certain figures, he had them cast full-size. (The enlarged *Thinker* emerged from this process in 1904 to become the world's most recognizable sculpture.) The result is a collection of thousands of plaster casts ranging from three inches to larger than life-size.

The second element that makes this story unique was the 1916 decision on the part of the French government to take a splendid eighteenth-century *hôtel particulier*, the Hôtel Biron, and to create within it a Musée Rodin. Never before had any state created a national museum dedicated to

the work of a single sculptor. The decision was contingent on Rodin's own gift. He gave everything he owned—all his sculptures, his plaster molds, his drawings, his prints, his personal art collection and his home in Meudon—to the State. With this gift came the legal right of the museum to make casts from the donated molds. This is significant since so many of Rodin's works, including *The Gates of Hell*, were not cast in his lifetime. After Rodin's death in 1917, the director of the new museum and the board of directors decided that a maximum of 12 casts could be taken of a single plaster.

Hence, a fruitful combination of events that has made Rodin sculptor to the world. A state commission that never came to fruition thus turning his major public work into a highly personal undertaking for which he made a startling number of figures over the course of his life; an extraordinarily beautiful museum in an eighteenth-century building that has become the third most visited museum in Paris, providing visitors with an opportunity to see Rodin's work in the context of his life; and the possibility of new casts made under the watchful eye of Musée Rodin curators.

For some years the Musée Rodin has commissioned its large casts (such as *The Gates* and *Burghers* in Seoul) from the Fonderie de Coubertin, a fine arts foundry noted for high quality work in the ancient tradition of bronze

Charcoal and gouache project for *The Gates of Hell*, 1880

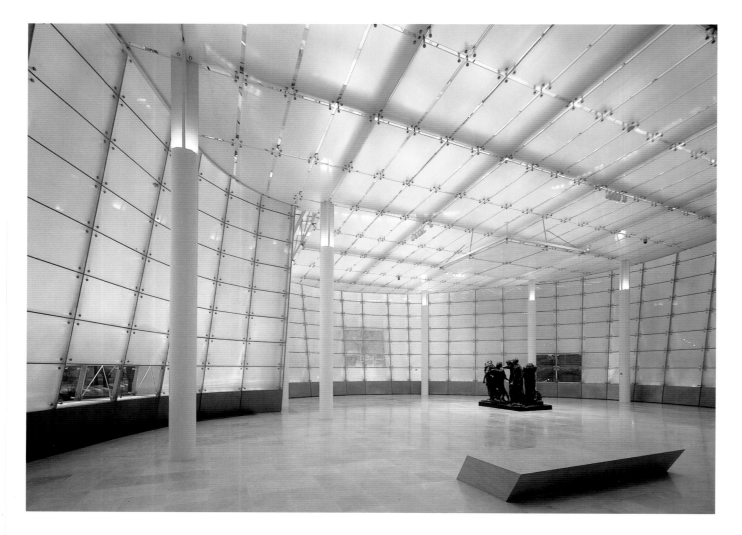

casting. *The Gates of Hell* in Seoul is Coubertin's third, and all were done in the *cire perdue* technique. The four earlier casts were done in the sand-cast method of the Rudier foundry. Scholars and enthusiasts who have seen all seven casts of *The Gates* are in general agreement that Coubertin's doors for Seoul are the most beautiful among them.

Once visitors to the gallery in Seoul have viewed the two monumental works in the main space, they can continue their visit among the auxiliary spaces suitable for smaller works. The 1999 opening exhibit, curated by Antoinette Le Normand-Romain, was an installation of Rodins from the Samsung and Musée Rodin, Paris collections. But curators in Seoul also have plans to use these light-filled spaces to show off the work of modern Korean artists—those unafraid to bend the rules, just as Rodin approached the rules of the sculptor's art in the 1860s and 1870s.

Regardless of the kind of art shown, Kevin Kennon's building will remain a "Rodin Gallery." It is quite possible that it will be the last such building solely dedicated to Rodin's work. A curator can certainly devise exhibitions with the master's smaller works, but a Rodin museum without an *Age of Bronze*, a large *Thinker*, a *Balzac*, or a *Burghers of Calais* is not possible. And *The Burghers of Calais* in Seoul is the last cast allowable. With the exception of *The Gates of Hell*, the great large studies will not be cast again by the Musée Rodin.

The most satisfying aspect of the Seoul museum is that the setting for these grand works has never been better: the shape of the space; the quality of the light; the luminosity of surface; and the cool, modulated use of color blend together to create a dazzling environment in which these extraordinarily well-known but no less truly great works can be considered afresh.

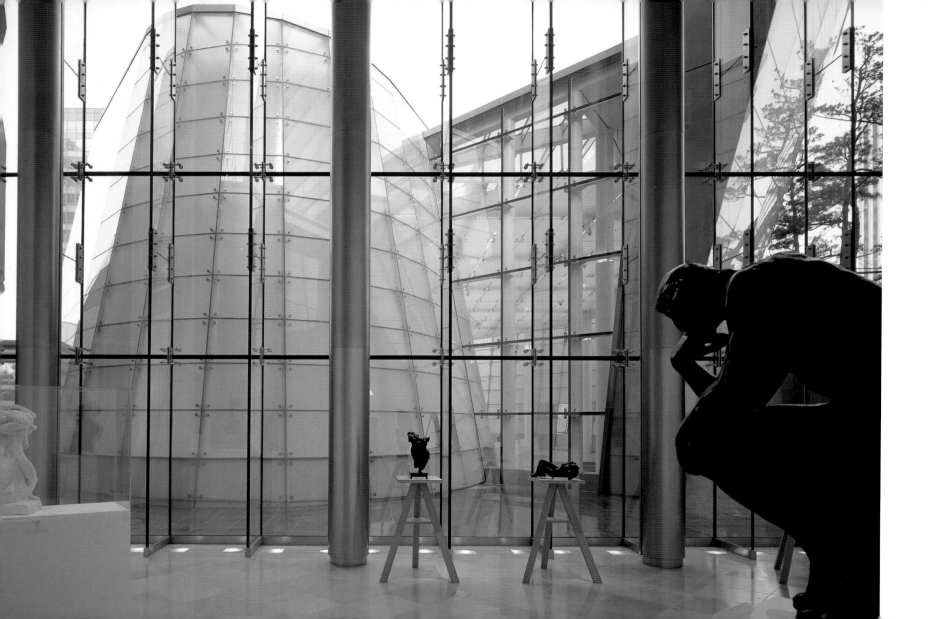

1 The first Rodin exhibition in South Korea was at the National Museum of Modern Art in 1985, and in 1993 there was a Rodin and Claudel show at the Dong-A Gallery in Seoul. In 1993 the Musée Rodin mounted a large exhibition that was shown in Hong Kong, Beijing, Taipei, and Shanghai. In 1994 the Shizuoka Prefectural Museum opened a large new wing devoted solely to the art of Rodin, including a cast of *The Gates of Hell*, and in 1998 the Musée Rodin aided the Japanese in mounting an exhibition of sculpture, drawings, and photographs that traveled to seven Japanese cities.

2 Besides Baron Matsukata's cast in Tokyo at the Museum of Western Art, there is a cast at the Musée Rodin in Paris, the Rodin Museum in Philadelphia, the Kunsthaus in Zurich, Stanford University in California, and at the Prefectural Museum in Shizuoka, Japan. *The Burghers of Calais* monument was inaugurated in Calais in 1895. The next cast, commissioned by Carl Jacobsen in 1903, is in the Ny Carlsberg Glyptotek in Copenhagen. Other casts are in Brussels, London, Paris, Basel, Tokyo, Philadelphia, Washington, D.C., Pasadena, California, and New York City.

I am indebted to Jacques Vilain, Director of the Musée Rodin in Paris, Antoinette Le-Normand Romain, Curator of Sculpture at the Musée Rodin, Kim Hyun-Jeong, Curator of the Rodin Gallery in Seoul, Hongnam Kim, Professor of Art History at Ewha Women's University, and Seung-Duk Kim, Curator of the Samsung Museum of Modern Art for their assistance in assembling the facts for this essay.

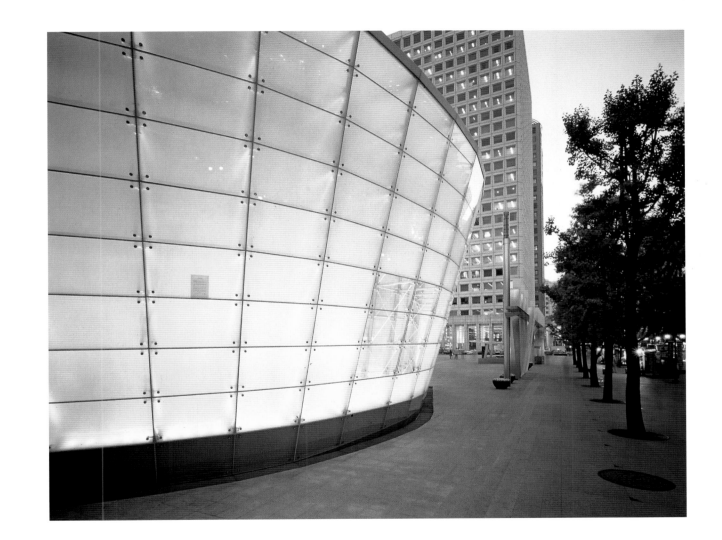

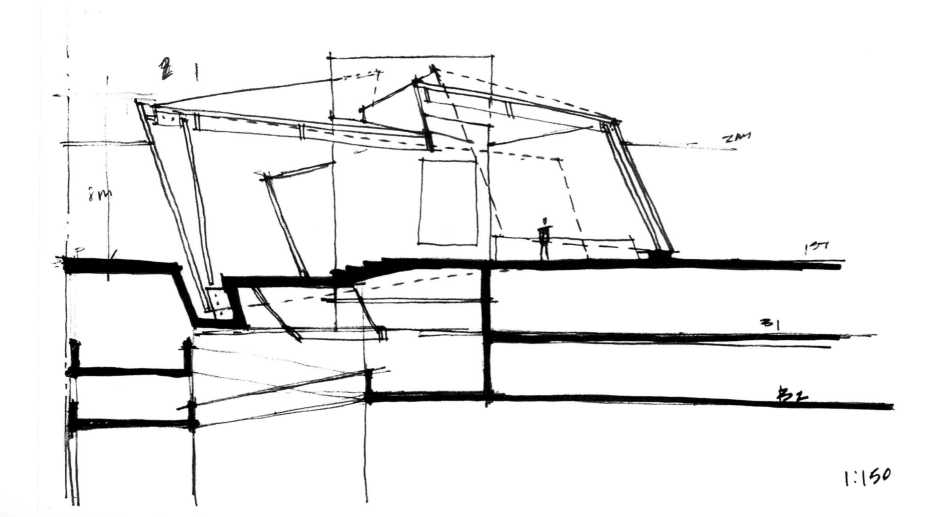

2AM

8m

1SM

B1

B2

1:150

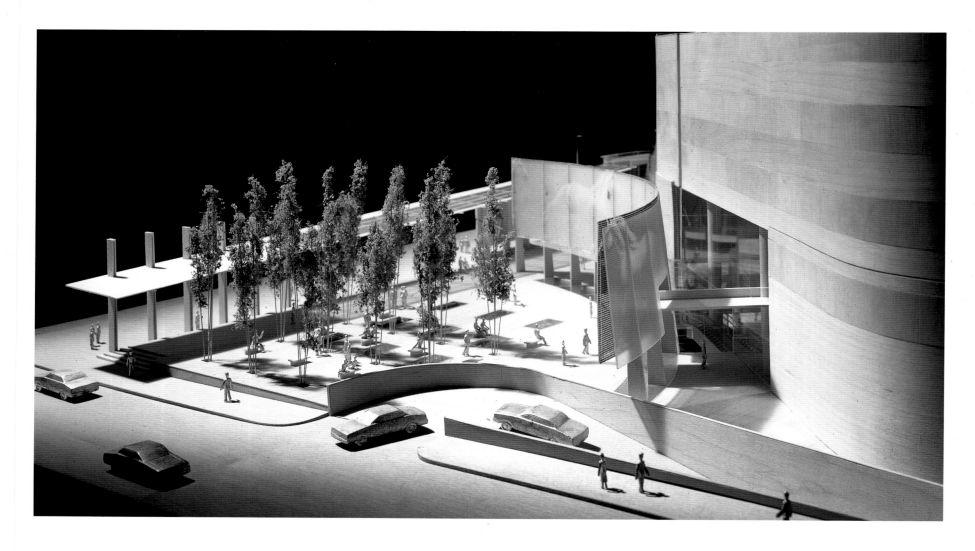

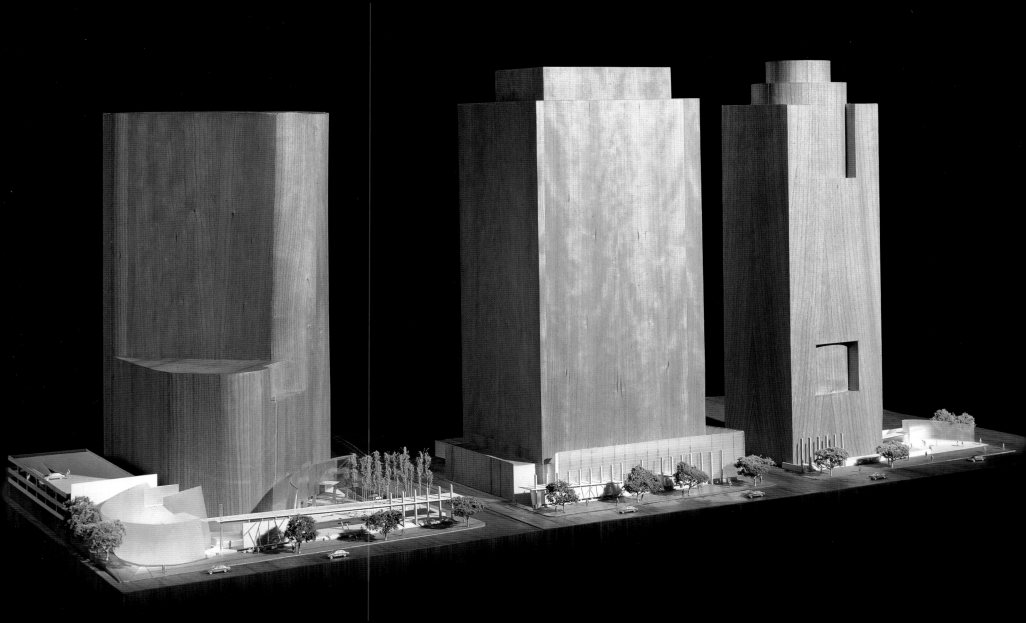

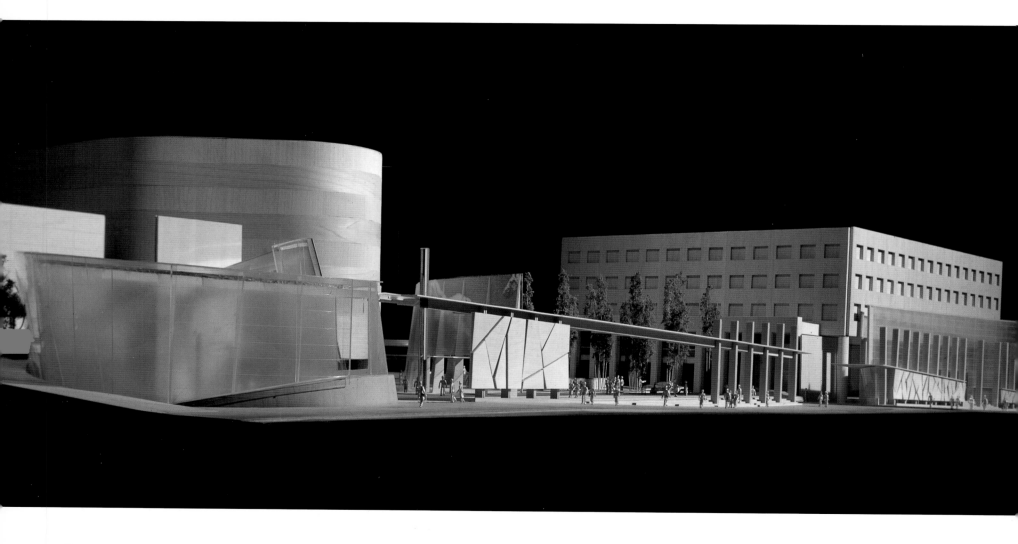

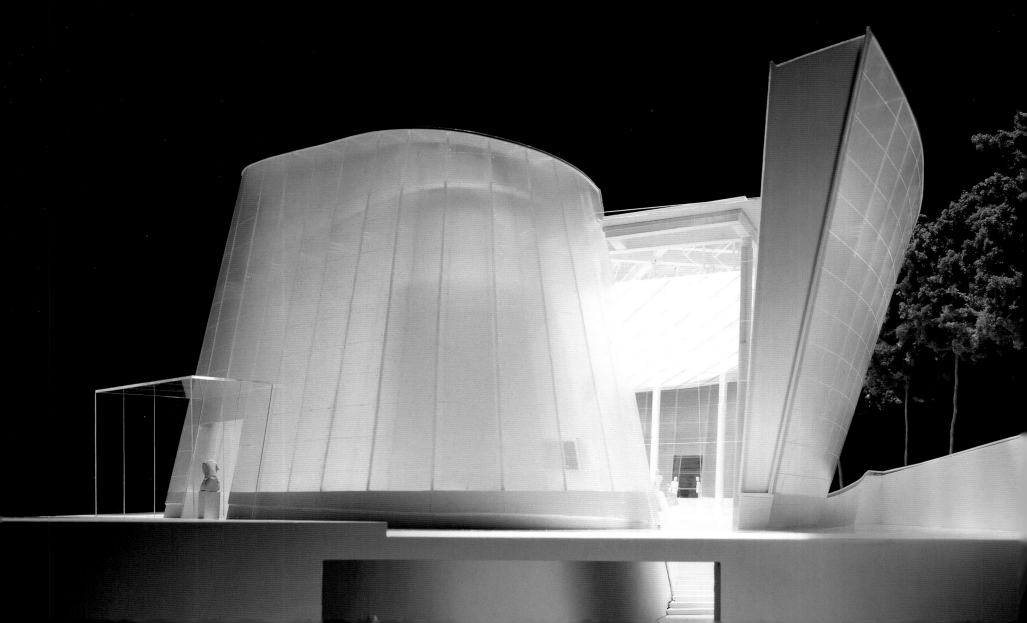

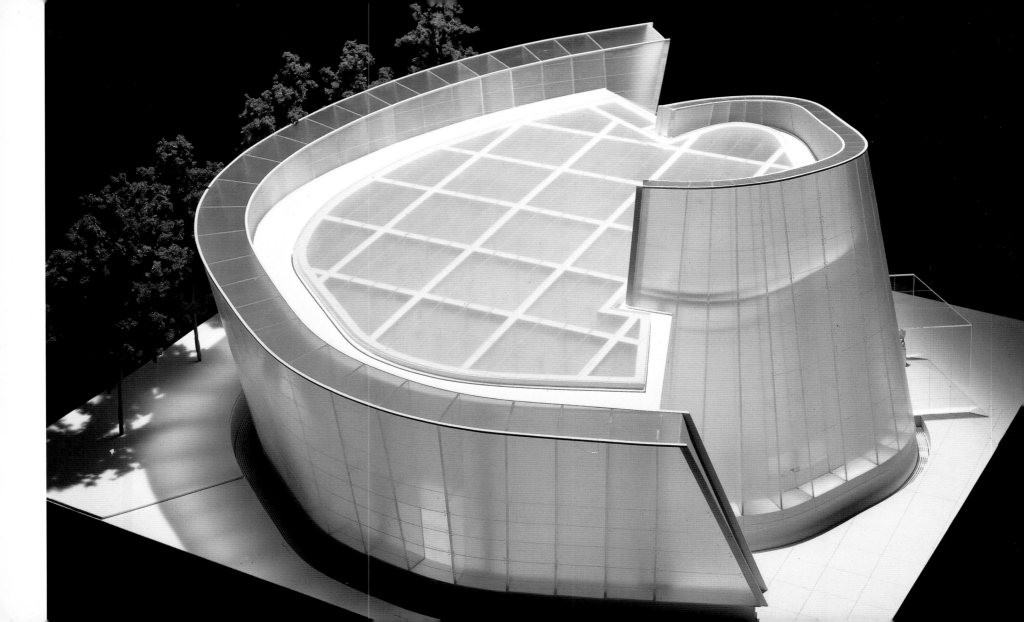

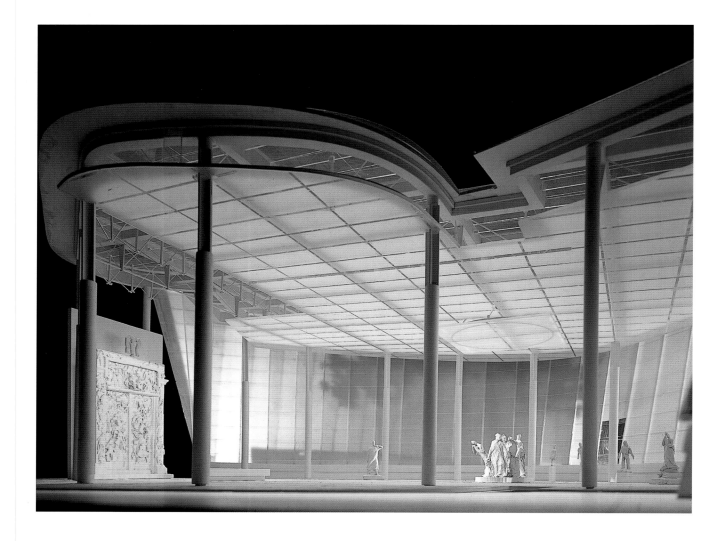

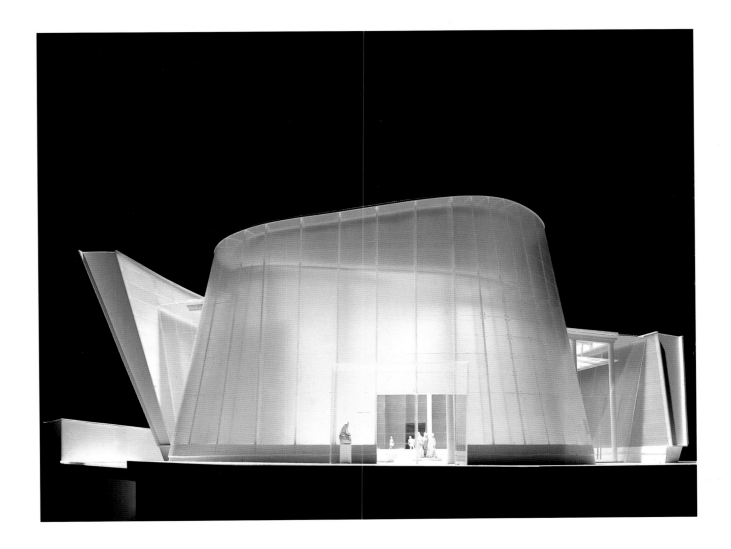

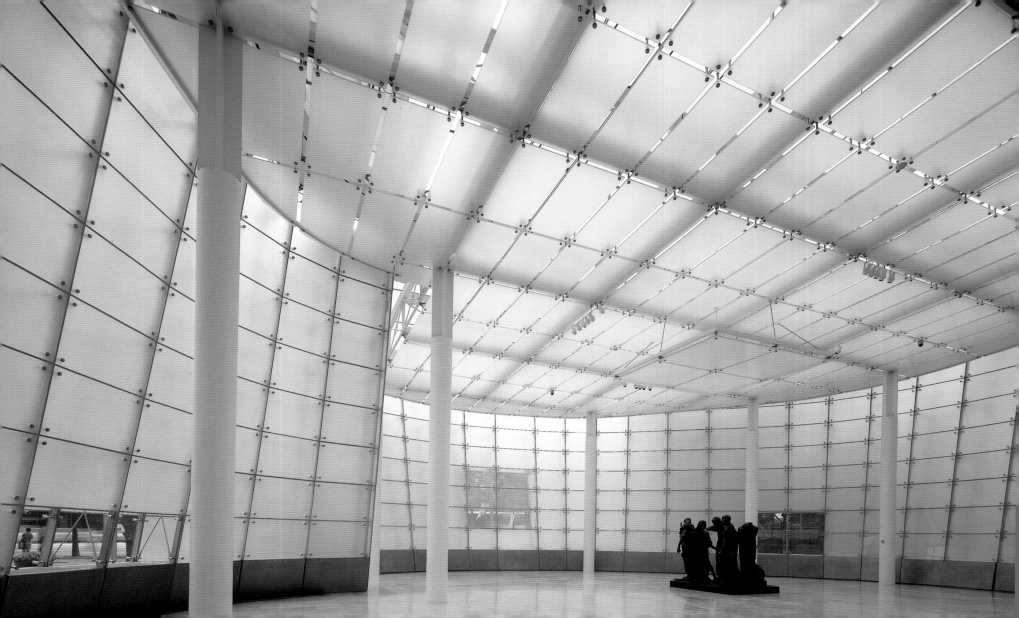

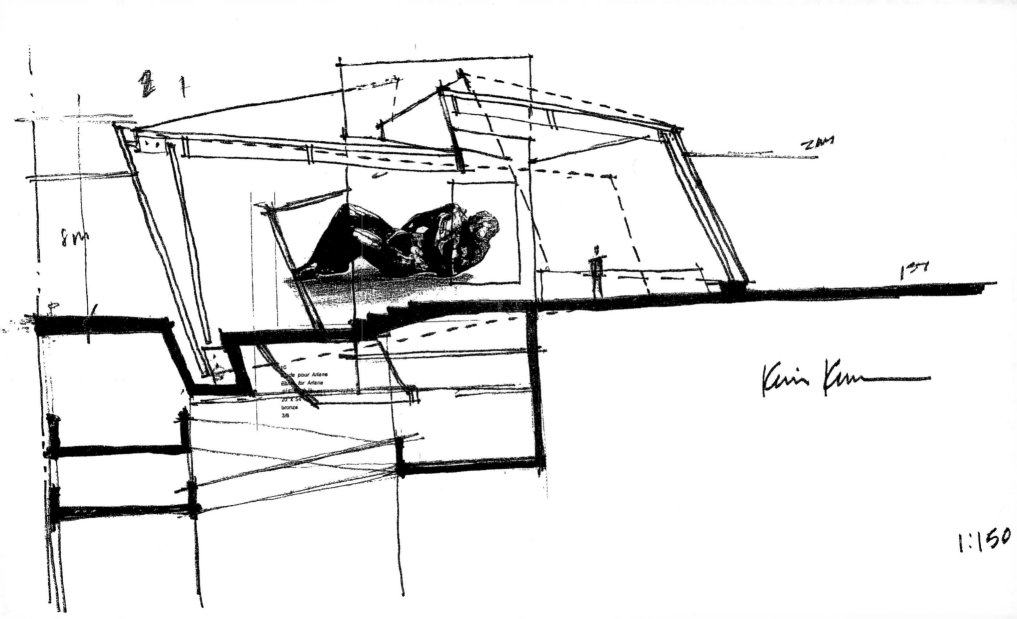

ZAM

8m

10
Étude pour Ariane
Étude for Ariane
20 x 54
bronze
3/8

Kevin Kerr

1:150

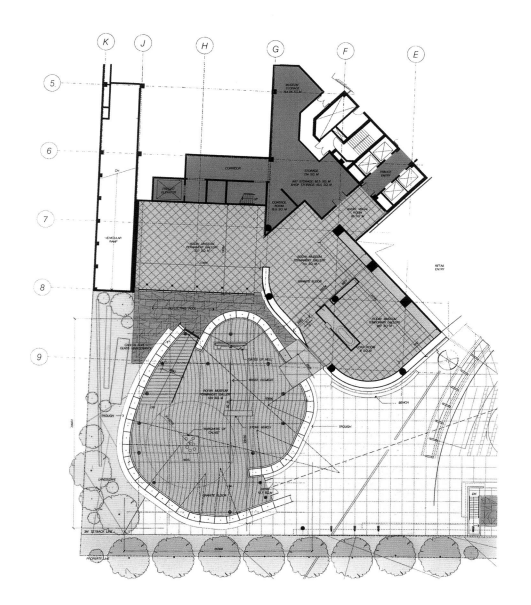

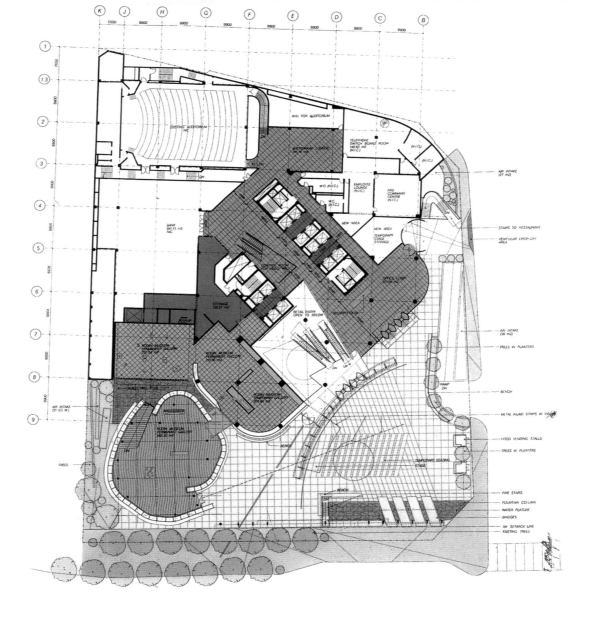

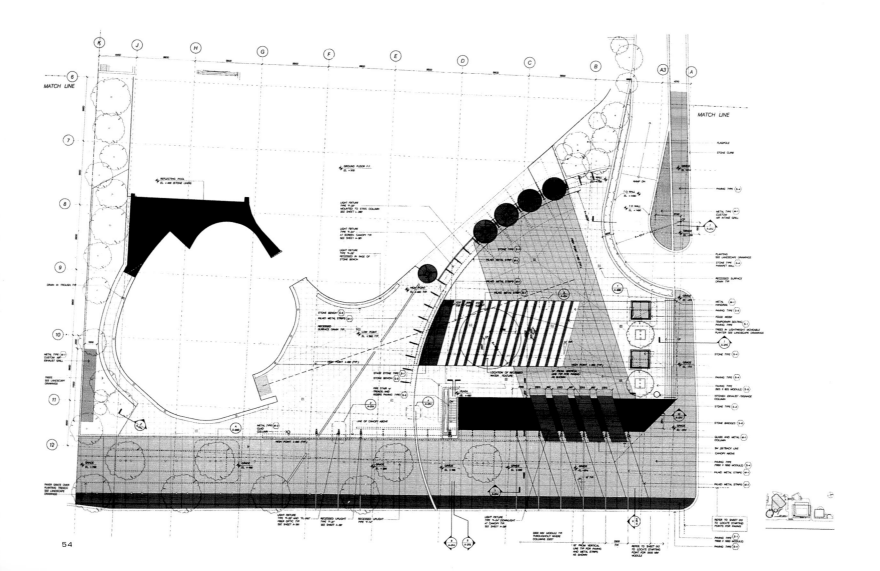

54

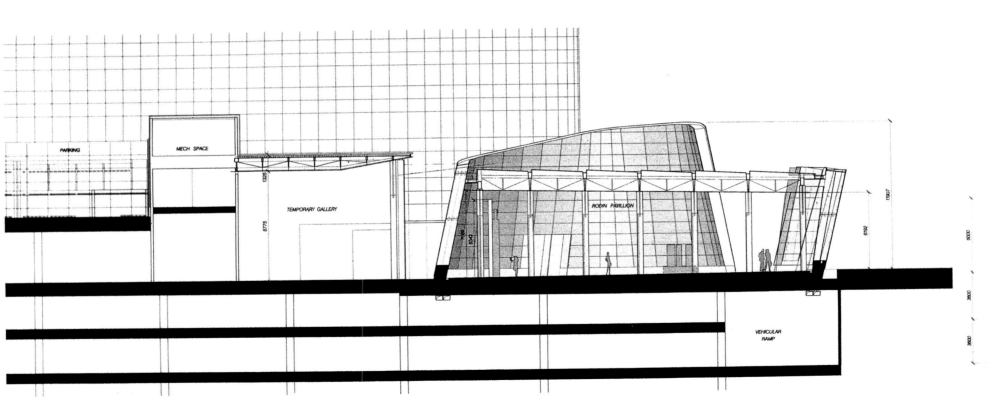

PARKING

MECH SPACE

TEMPORARY GALLERY

RODIN PAVILLION

VEHICULAR
RAMP

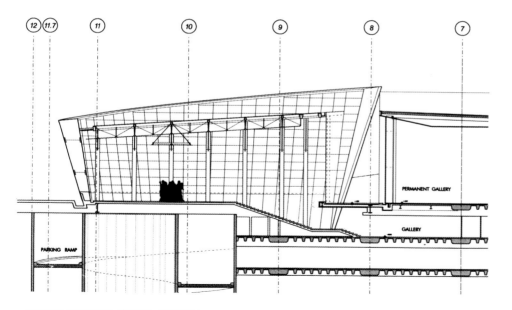

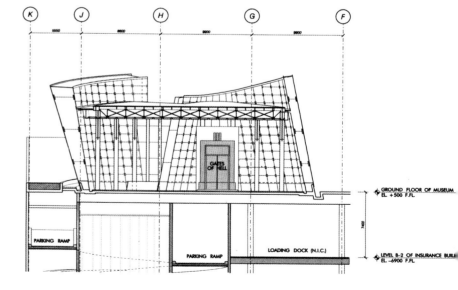

SECTION THROUGH MUSEUM PAVILLION

SECTION THROUGH MUSEUM PAVILLION

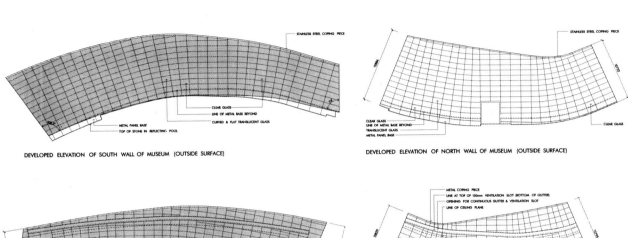

DEVELOPED ELEVATION OF SOUTH WALL OF MUSEUM (OUTSIDE SURFACE)

DEVELOPED ELEVATION OF NORTH WALL OF MUSEUM (OUTSIDE SURFACE)

DEVELOPED ELEVATION OF SOUTH WALL OF MUSEUM (INSIDE SURFACE)

DEVELOPED ELEVATION OF NORTH WALL OF MUSEUM (INSIDE SURFACE)

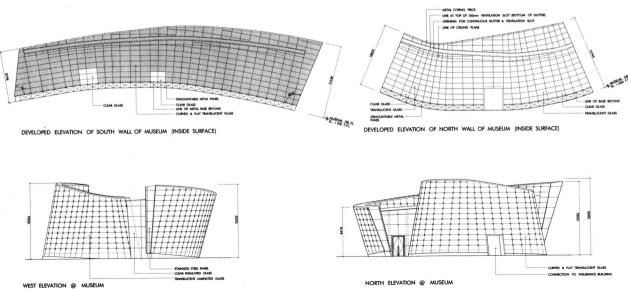

WEST ELEVATION @ MUSEUM

NORTH ELEVATION @ MUSEUM

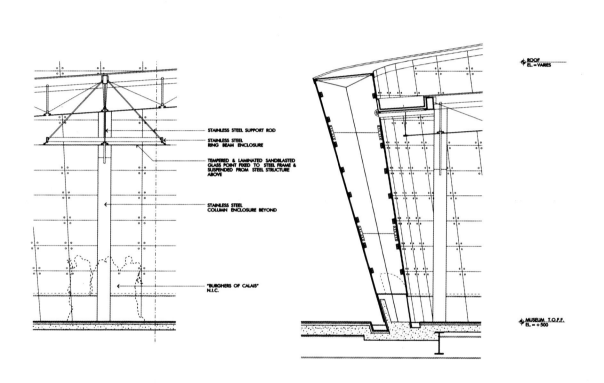

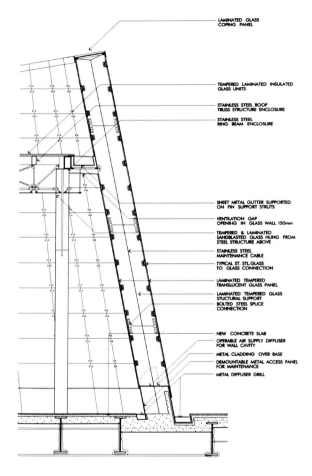

STAINLESS STEEL SUPPORT ROD

STAINLESS STEEL
RING BEAM ENCLOSURE

TEMPERED & LAMINATED SANDBLASTED
GLASS POINT FIXED TO STEEL FRAME &
SUSPENDED FROM STEEL STRUCTURE
ABOVE

STAINLESS STEEL
COLUMN ENCLOSURE BEYOND

"BURGHERS OF CALAIS"
N.I.C.

ROOF
EL. = VARIES

MUSEUM T.O.F.F.
EL. = +500

LAMINATED GLASS
COPING PANEL

TEMPERED LAMINATED INSULATED
GLASS UNITS

STAINLESS STEEL ROOF
TRUSS STRUCTURE ENCLOSURE

STAINLESS STEEL
RING BEAM ENCLOSURE

SHEET METAL GUTTER SUPPORTED
ON FIN SUPPORT STRUTS

VENTILATION GAP
OPENING IN GLASS WALL 150mm

TEMPERED & LAMINATED
SANDBLASTED GLASS HUNG FROM
STEEL STRUCTURE ABOVE

STAINLESS STEEL
MAINTENANCE CABLE

TYPICAL ST. STL.GLASS
TO GLASS CONNECTION

LAMINATED TEMPERED
TRANSLUCENT GLASS PANEL

LAMINATED TEMPERED GLASS
STUCTURAL SUPPORT

BOLTED STEEL SPLICE
CONNECTION

NEW CONCRETE SLAB

OPERABLE AIR SUPPLY DIFFUSER
FOR WALL CAVITY

METAL CLADDING OVER BASE

DEMOUNTABLE METAL ACCESS PANEL
FOR MAINTENANCE

METAL DIFFUSER GRILL

LOWERED CEILING PLANE OVER THE "BURGHERS OF CALAIS" **DETAIL WALL SECTION THROUGH LEFT WALL OF MUSEUM** **DETAIL WALL SECTION THROUGH RIGHT WALL OF MUSEUM**

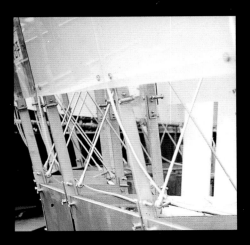

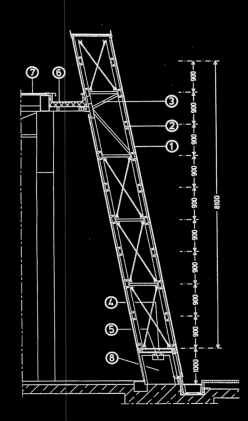

1 Verbundsicherheitsglas
2 Glashaltepunktausbildung
3 Distanzausbildung
4 Gitterrost
5 Befestigung
6 Regenrinne
7 Dachkonstruktion
8 Konvektorschacht

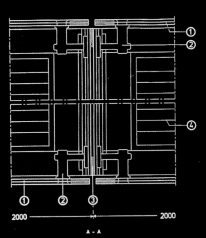

1 Laminated glazing
2 Glass point fixtures
3 Spacers
4 Grilles
5 Brackets
6 Rain water gutter
7 Roof structure
8 Convector shaft

A - A

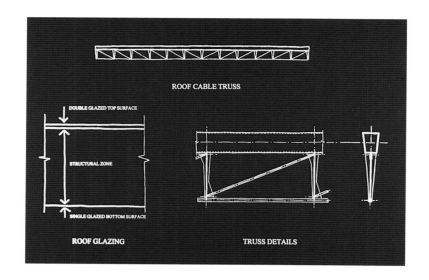

ROOF CABLE TRUSS

DOUBLE GLAZED TOP SURFACE

STRUCTURAL ZONE

SINGLE GLAZED BOTTOM SURFACE

ROOF GLAZING TRUSS DETAILS

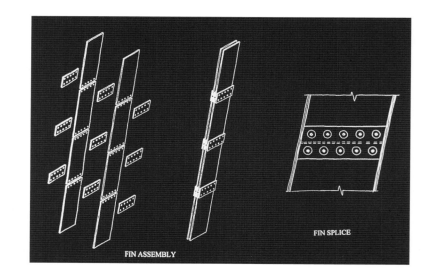

FIN SPLICE

FIN ASSEMBLY

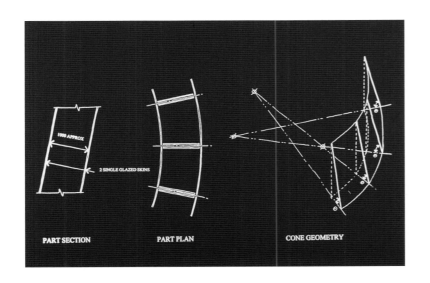

PART SECTION

1000 APPROX

2 SINGLE GLAZED SKINS

PART PLAN

CONE GEOMETRY

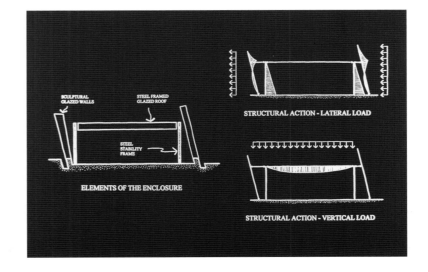

SCULPTURAL GLAZED WALLS

STEEL FRAMED GLAZED ROOF

STEEL STABILITY FRAME

ELEMENTS OF THE ENCLOSURE

STRUCTURAL ACTION - LATERAL LOAD

STRUCTURAL ACTION - VERTICAL LOAD

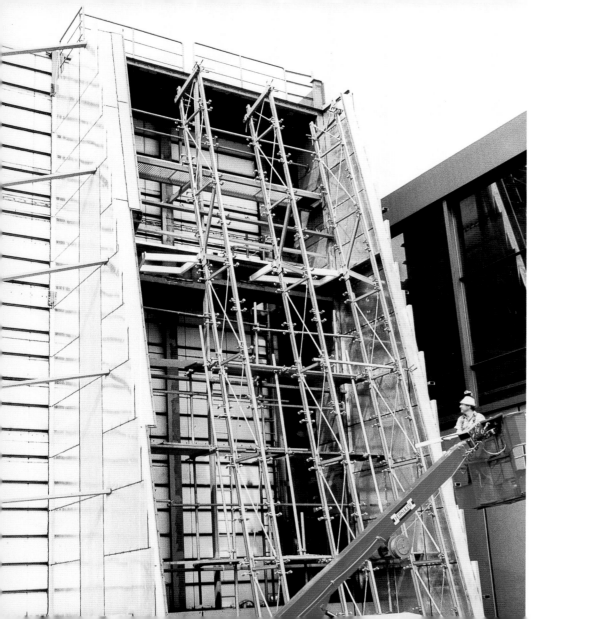

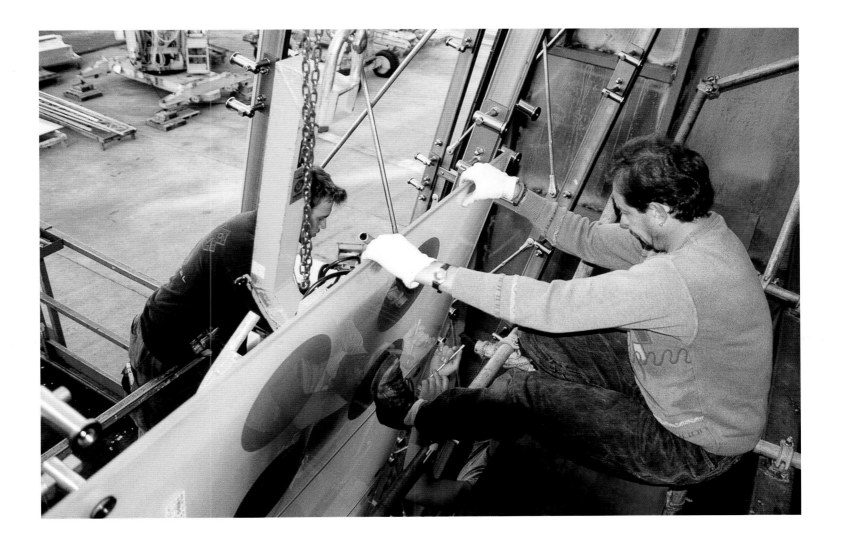

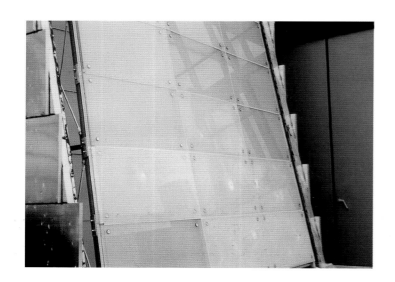

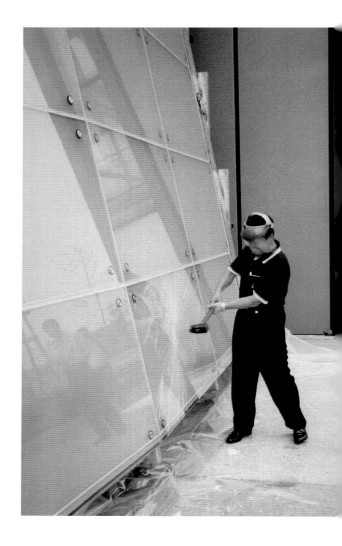

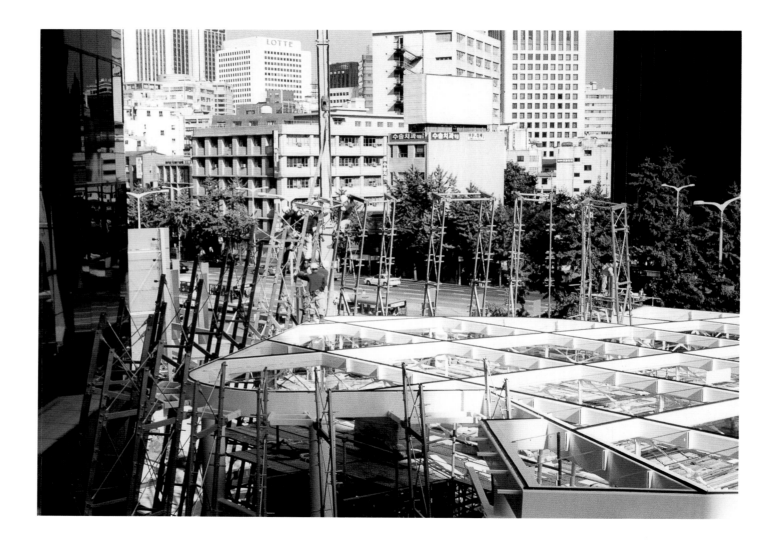

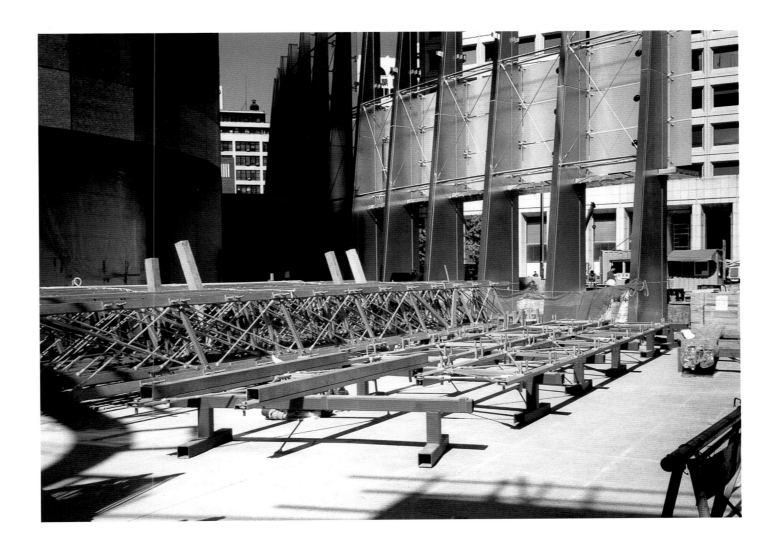

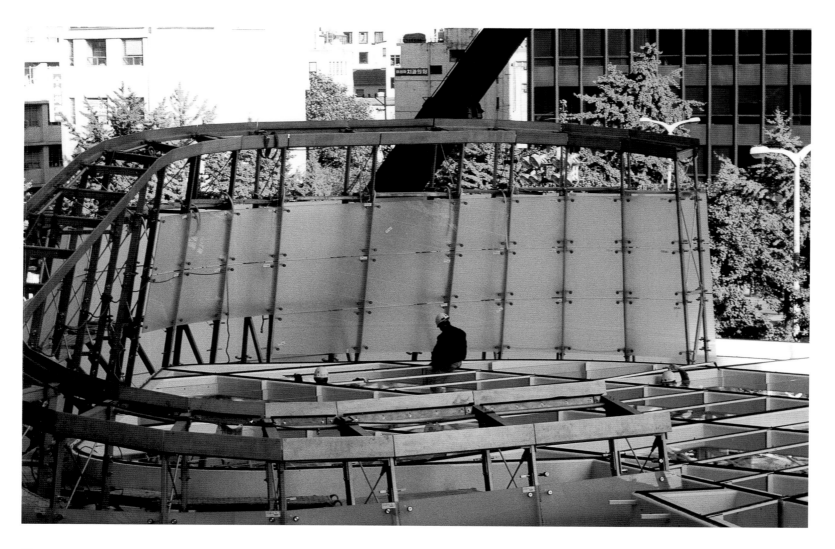

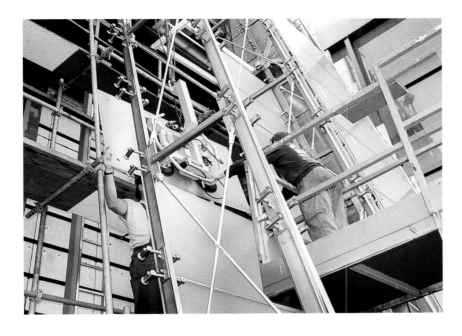
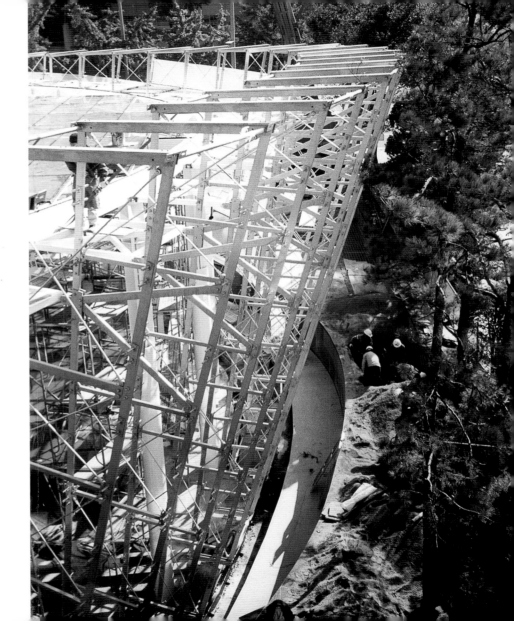

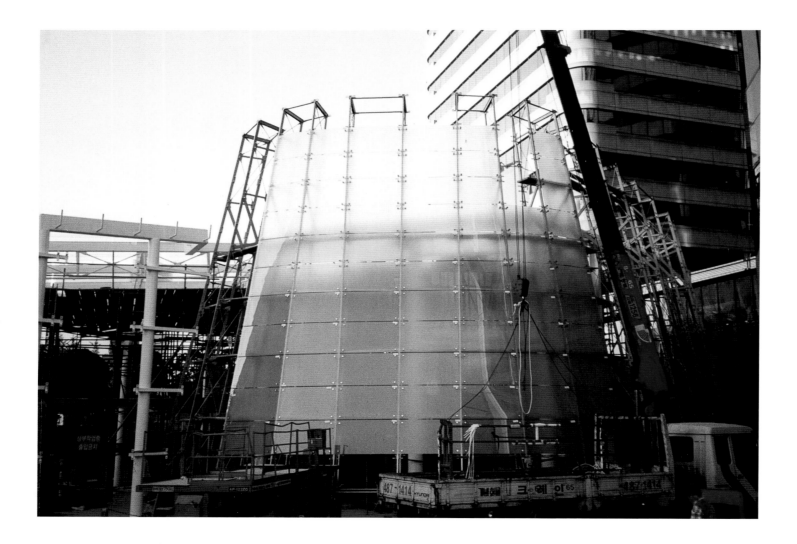

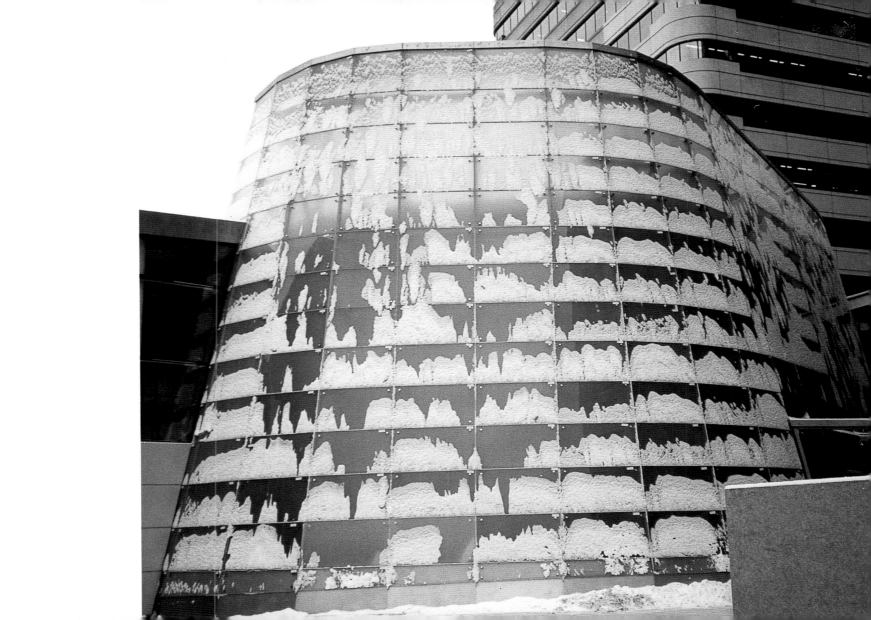

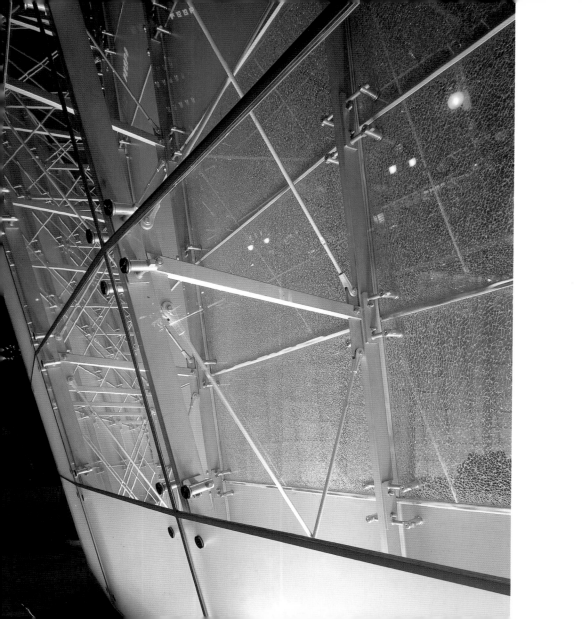

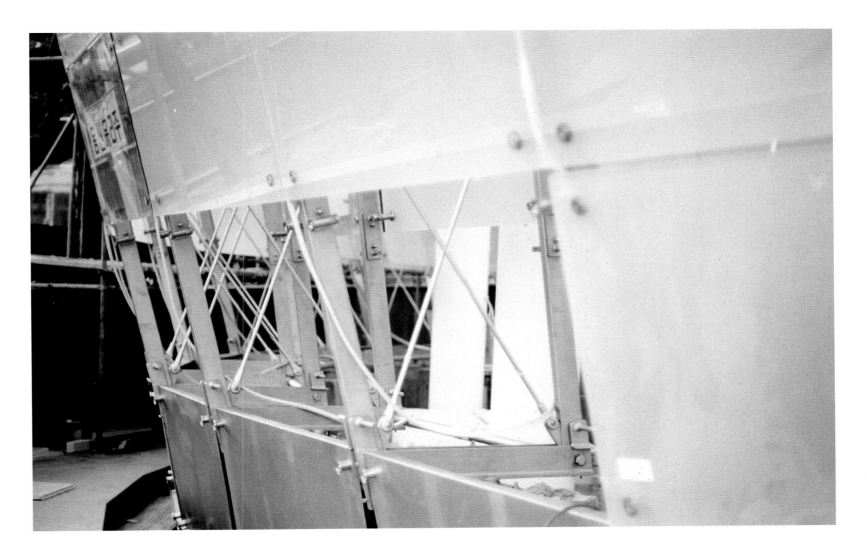

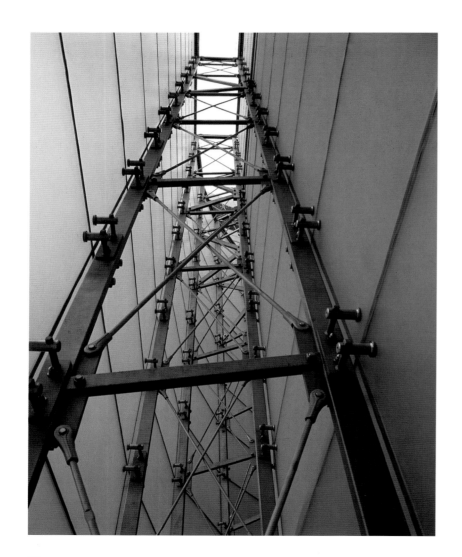

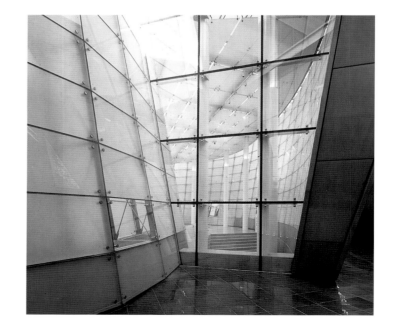

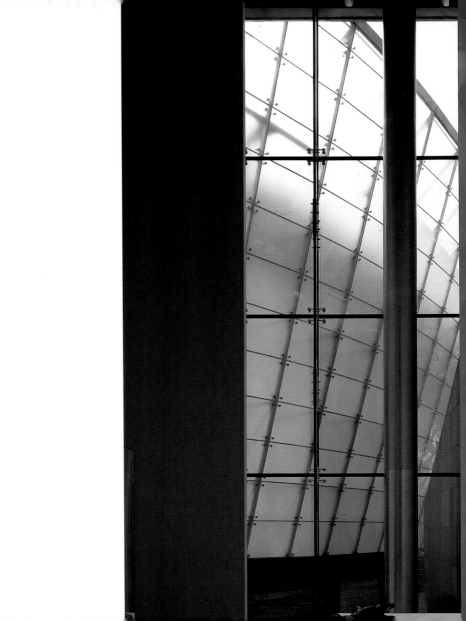

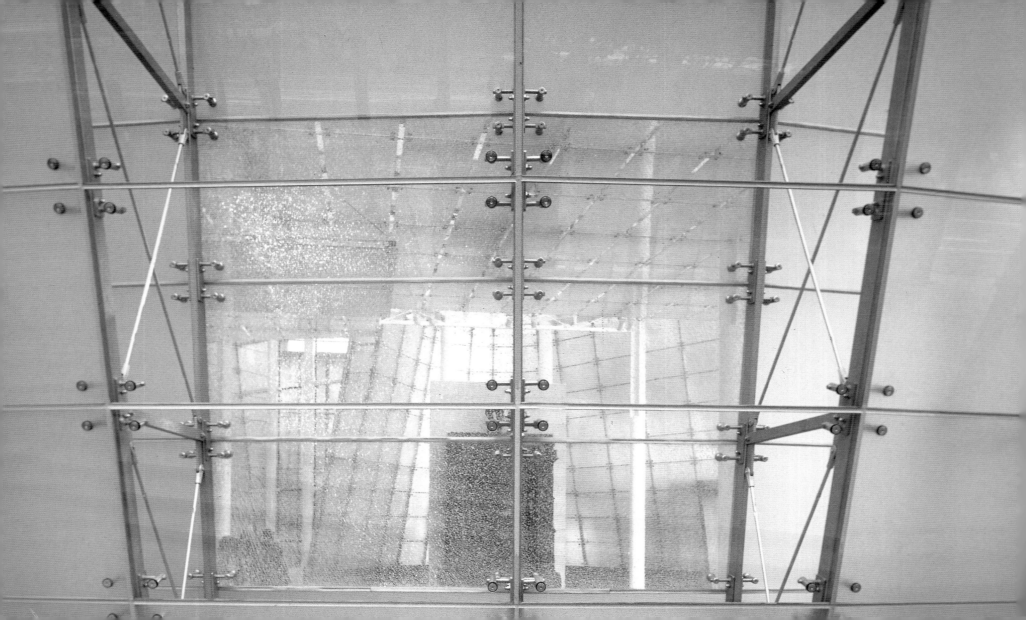

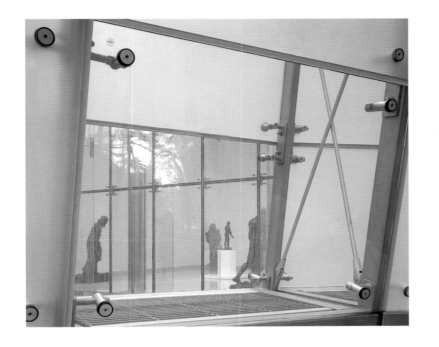

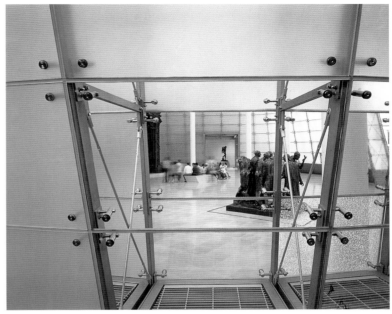

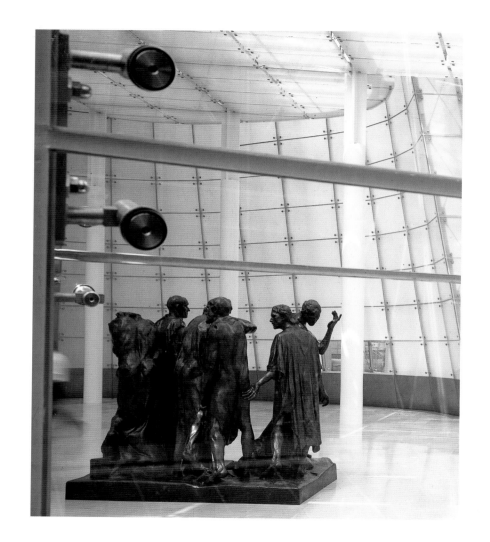

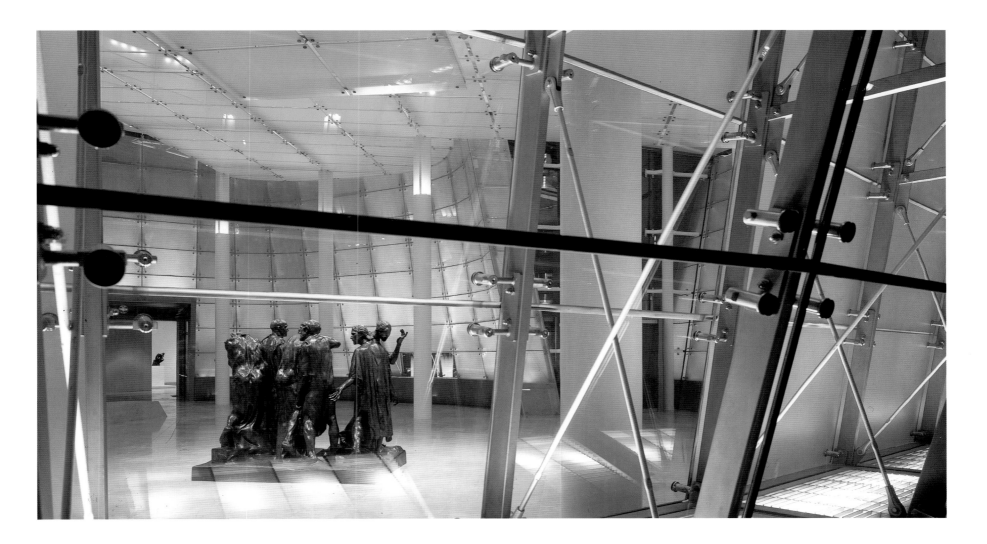

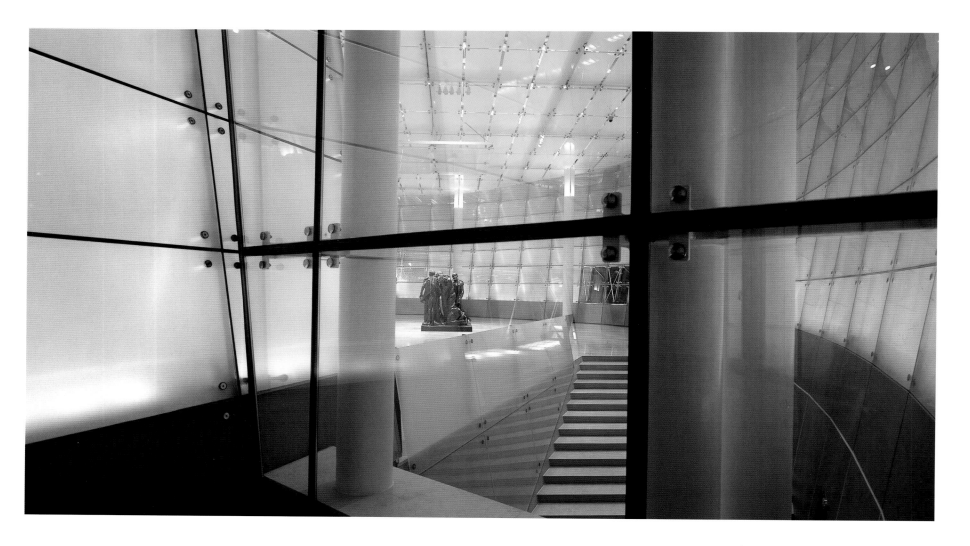

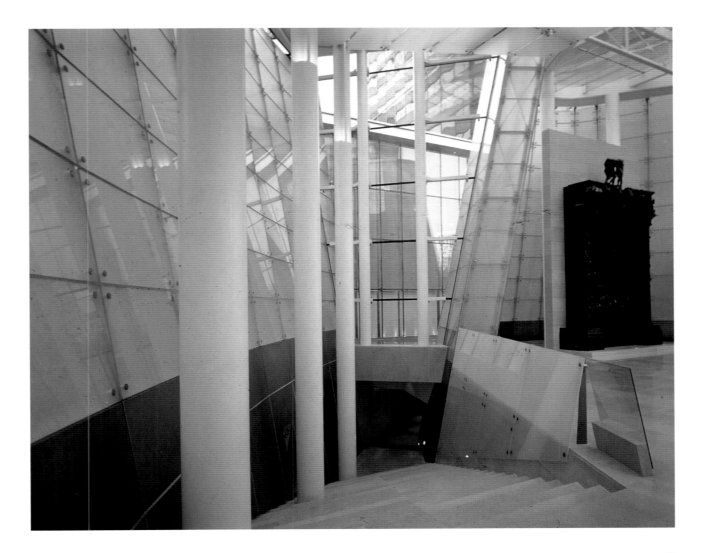

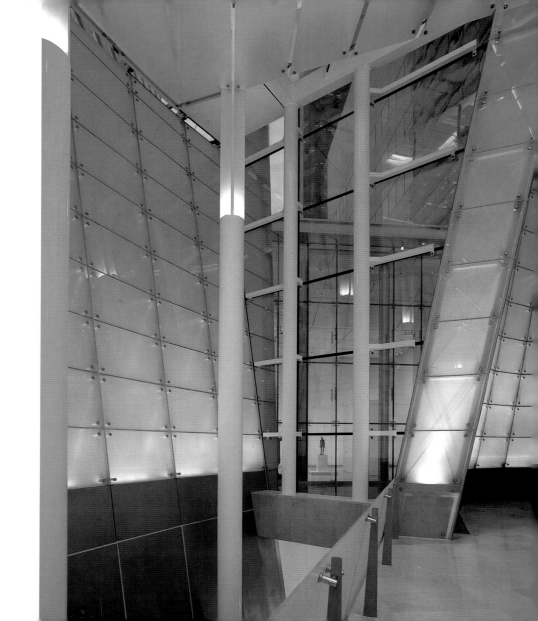

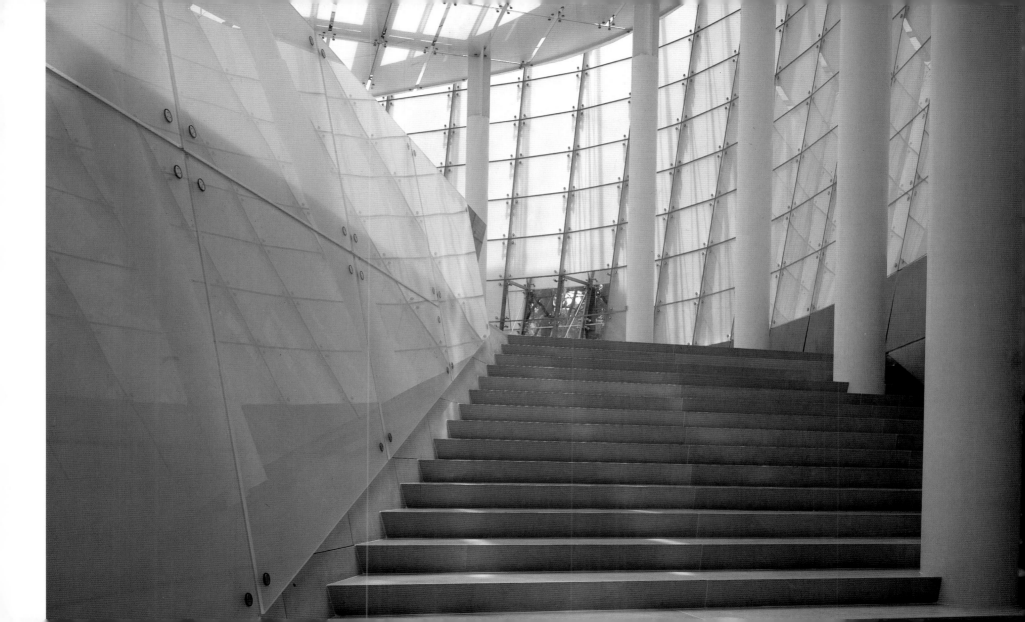

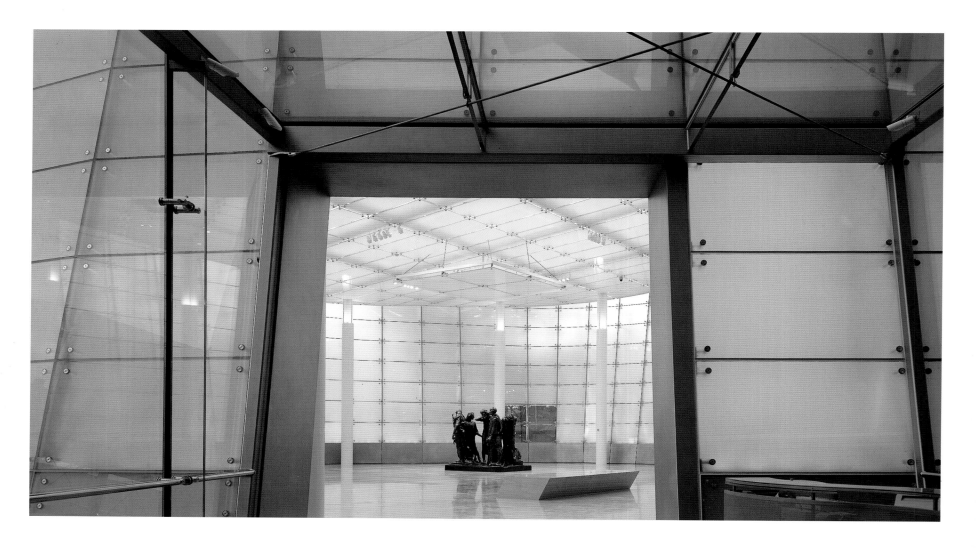

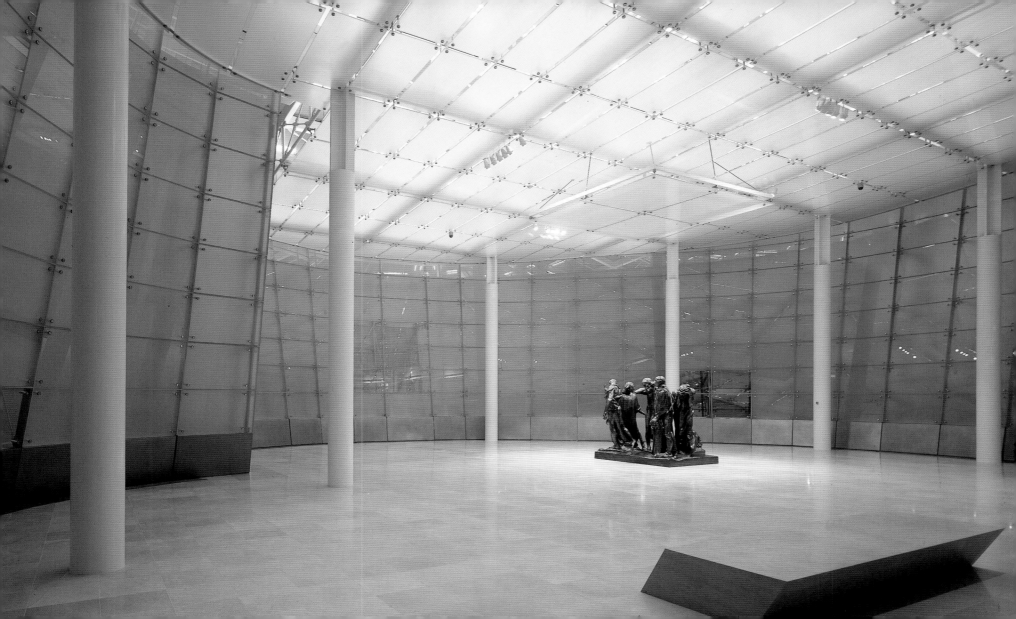

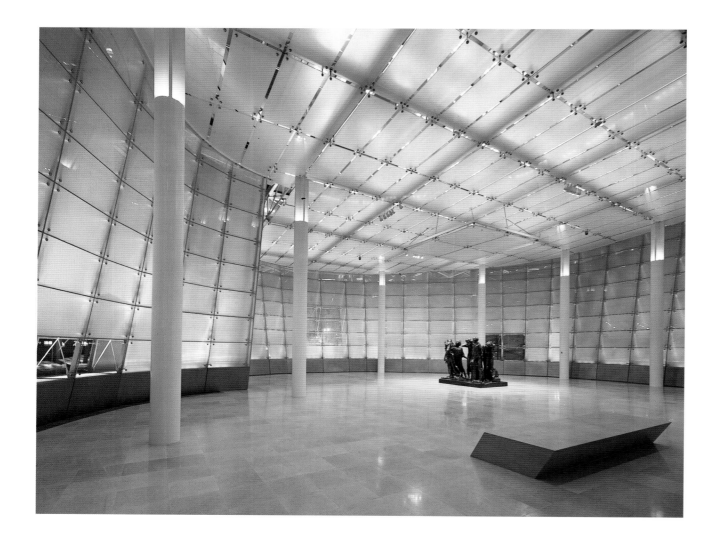

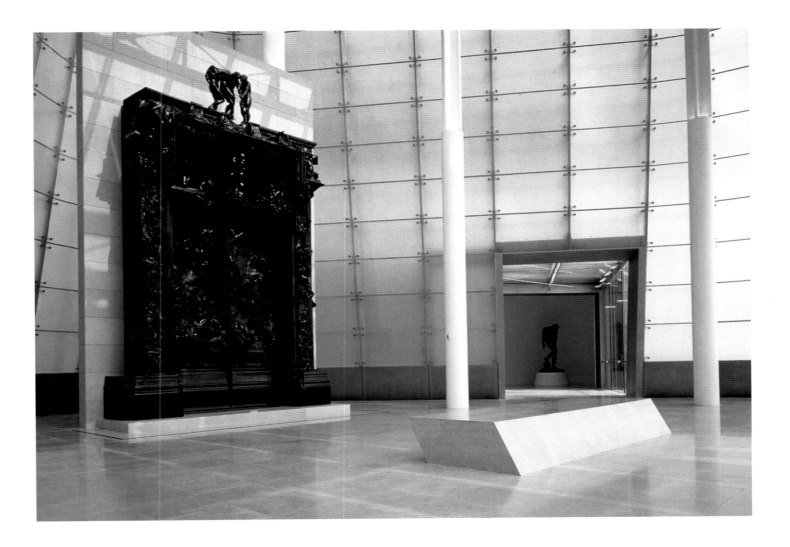

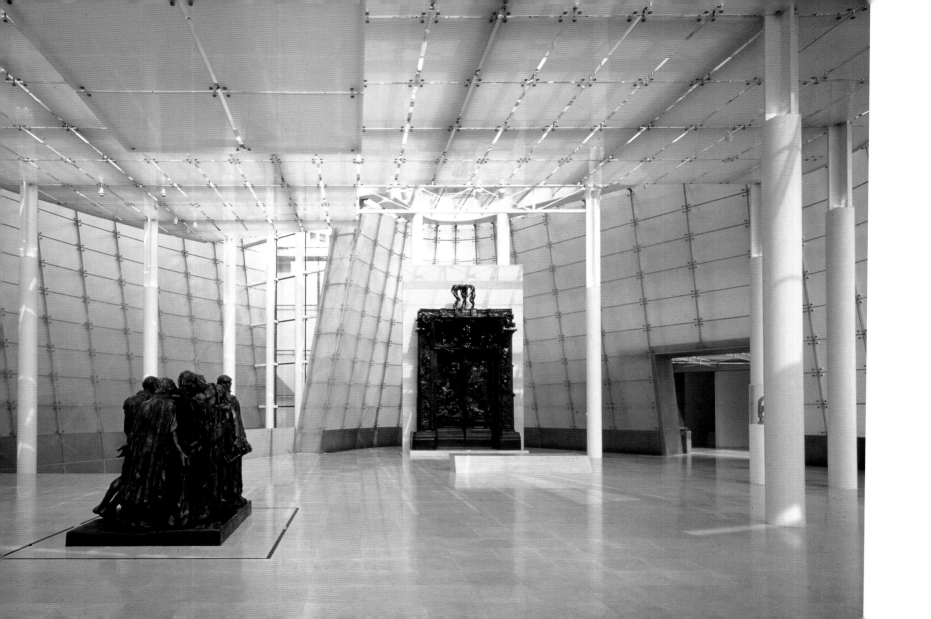

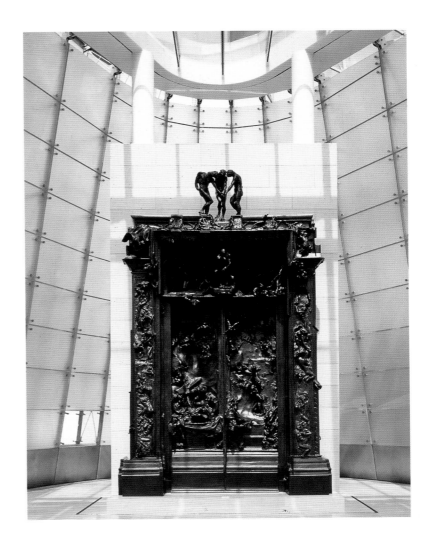

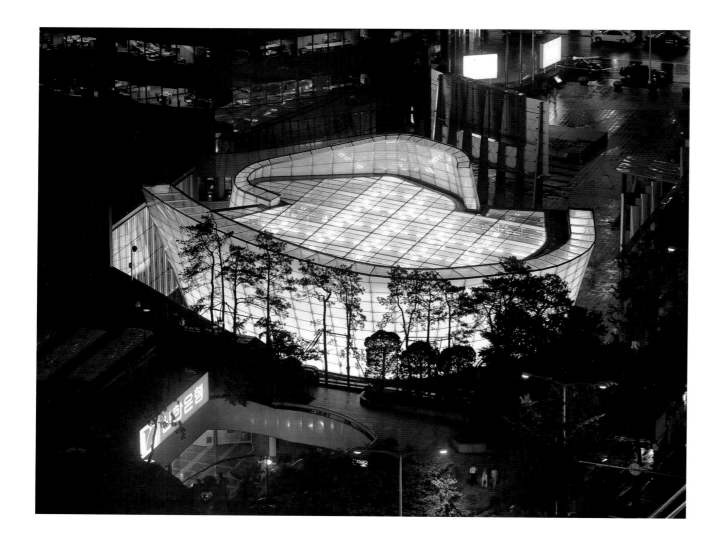

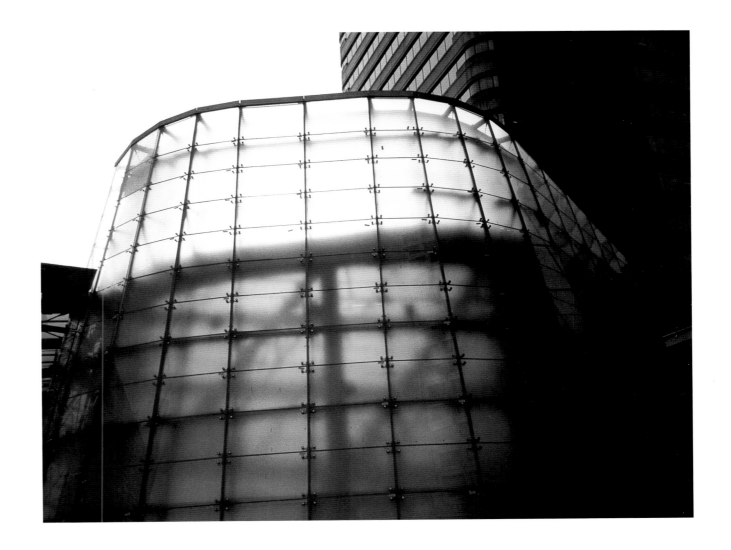

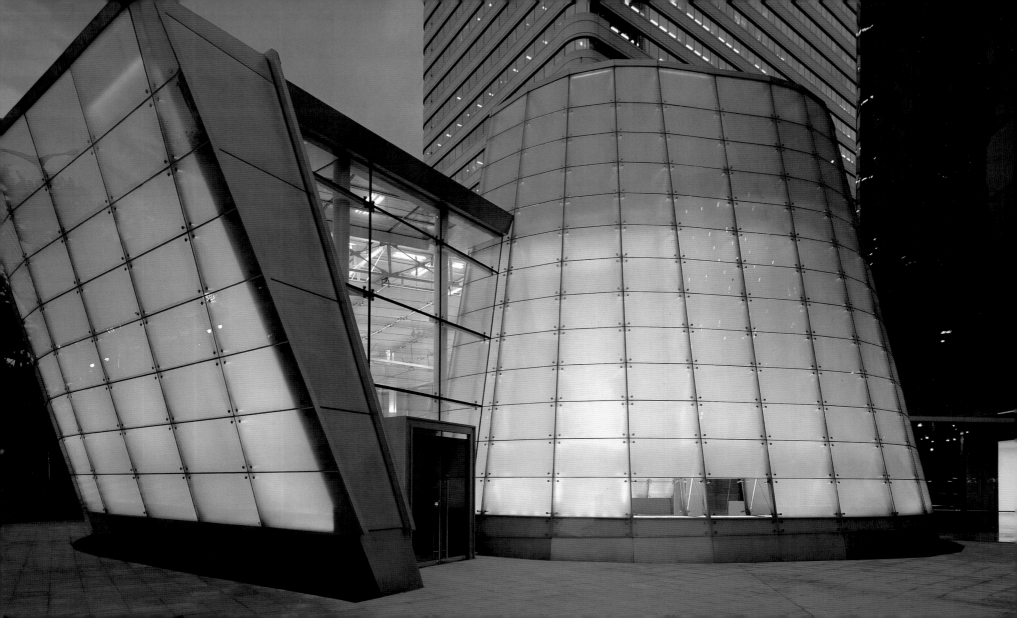

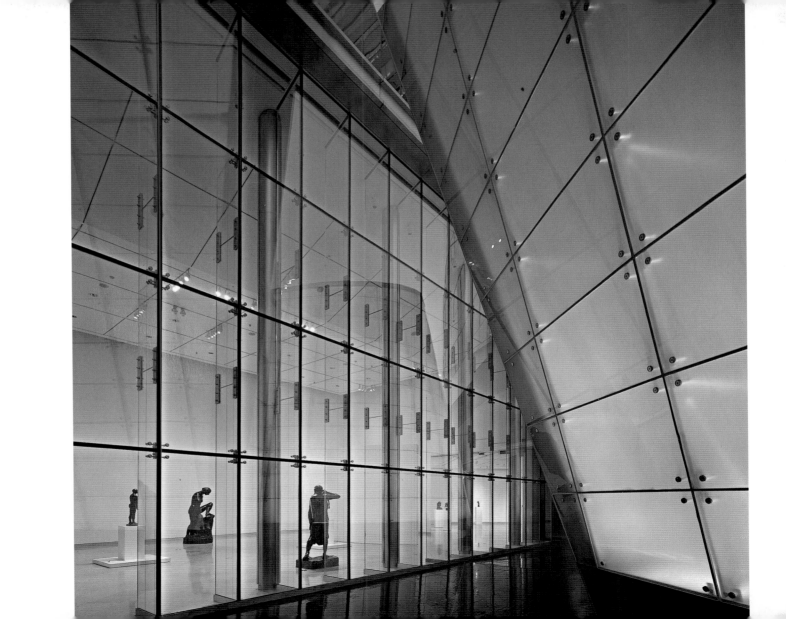

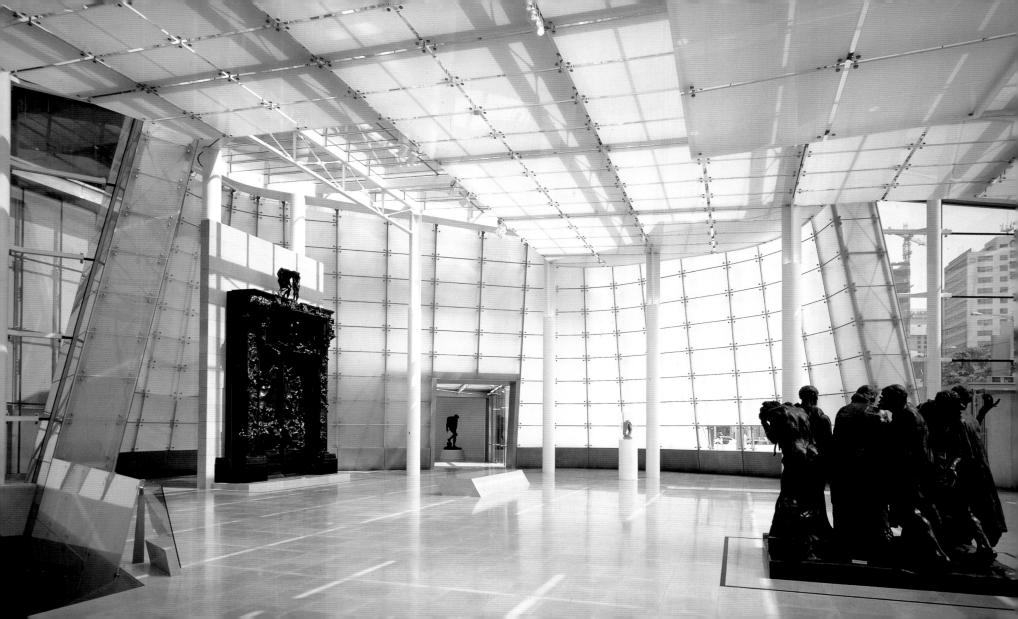

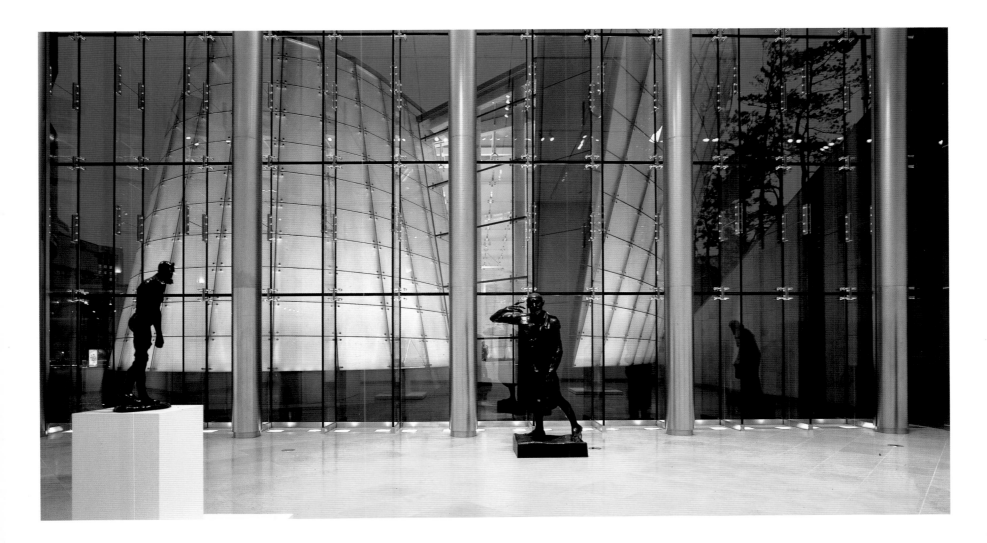

Project Team

DESIGN PRINCIPAL	Kevin Kennon
PROJECT PRINCIPAL	Gregory Clement
PROJECT MANAGER	Andreas Hausler
DESIGN TEAM LEADERS	Marianne Kwok, Luke Fox
COORDINATION LEADER	Francis Freire
TEAM	Vladimir Balla, Christopher Ernst, Andrew Kawahara, John Locke, Michael Marcolini, Chulhong Min, Cordula Roser, Aida Saleh, Trent Tesch
ASSOCIATE ARCHITECT	Samoo Architects & Engineers (Samsung)
OWNER	Samsung Group
MECHANICAL ENGINEER	Cosentini Associates
STRUCTURAL ENGINEER	Ove Arup & Partners
LANDSCAPE ARCHITECT	Rolland/Towers
LIGHTING DESIGN CONSULTANT	Thomas Thompson Lighting Design
SPECIALTY STONE ARTIST	Gary Haven Smith Studio
EXTERIOR WALL CONSULTANT	Heitmann & Associates
GLASS CONSULTANT	James Carpenter Design Associates
SPECIALTY GLASS FITTINGS CONSULTANT	Tripyramid Structures
GENERAL CONTRACTOR	Joseph Gartner & Co.
GLASS CONTRACTOR	Bruder Eckelt & Co.

Image Credits